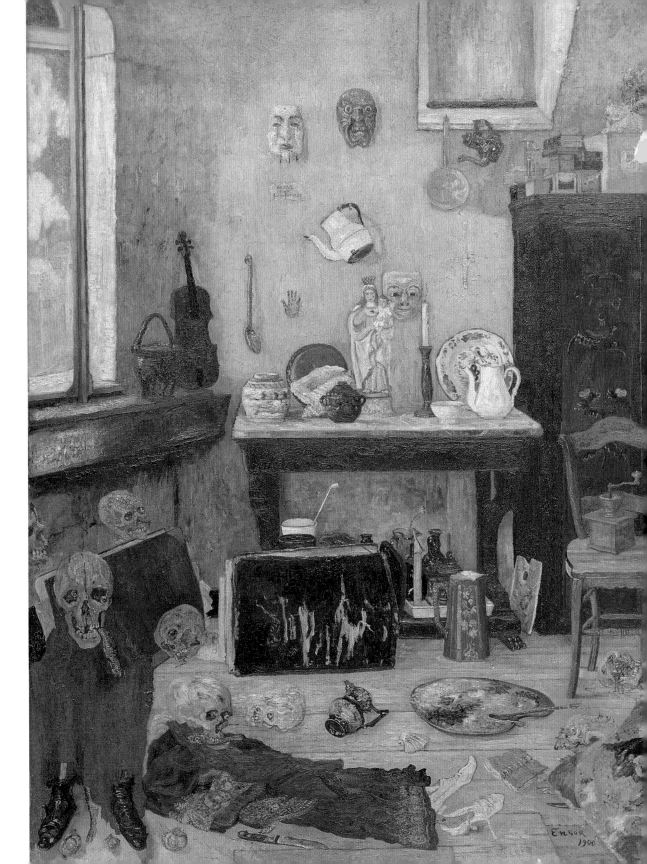

TASCHEN

KÖLN LONDON LOS ANGELES MADRID PARIS TOKYO

Fantastic Art

WALTER SCHURIAN
UTA GROSENICK (ED.)

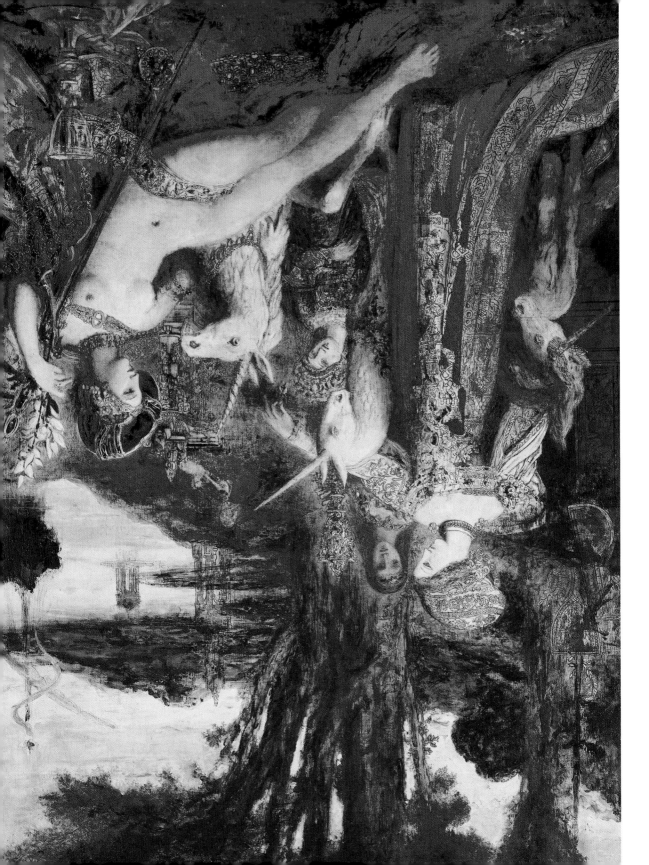

contents

beyond
mere understanding

The fantastic in art is present in such many-layered effulgence that at first it is difficult to know where to start and where to stop. This is because it is not a descriptive term that can be applied to any particular historical movement, and its features are in most cases only recognized and identified with hindsight. For example the Netherlandish painter Hieronymus Bosch (1450–1516) did not belong to a Fantastic school with a capital "F": it was only after his previously inconceivable, and thus for the moment incredible, strange and disturbing pictures, such as *The Garden of Earthly Delights*, *The Temptation of St Anthony* and *The Ship of Fools*, had the public as such rubbing their eyes in disbelief that critics set about categorizing these paintings thus – not least because he alluded to an inventory of fantastical creatures with which medieval people were familiar.

After the Second World War painters such as Rudolf Hausner, Ernst Fuchs, Arik Brauer, Wolfgang Hutter and Anton Lehmden unleashed their disturbingly alien pictures on to a Viennese art scene otherwise totally devitalised by the cultural policy of the Third Reich, and the public reacted with a mixture of enthusiasm on the one hand and incomprehension, apathy and rage on the other. It was against this background that the Viennese critic Johann Muschik coined the term "Vienna School of Fantastic Realism" to categorize this peculiar art and thus make it mentally accessible to a broader public.

When in the 1960s the Colombian artist Fernando Botero introduced his ample figures, comical dogs and other creatures to startled, amused or irritated beholders, the art critics set about categorizing this colourfully fleshed-out universe of highly peculiar characters along familiar lines: specifically, they sought to associate them with the stylistic methods of Pop Art.

In other cases, however, attempts to find a conceptual home for art which fits into no known category sanctioned by artistic tradition have come to nothing. A complicating factor is no doubt that recognized trends have all had their fantastic component, so that demarcation is apt to be fuzzy. In the 20th century for example it has been difficult to draw any dividing line between Fantastic Art and Surrealism, Magic Realism, the Art of the Absurd, or the Art of the Insane, whose best-known exponent was Adolf Wölfli (1864–1930). Thus Salvador Dalí is assigned to Surrealism, but who could doubt that this eccentric Spaniard was also one of the greatest fantastic artists? After all, it was not least through his lifestyle, his writings and his widely disseminated art that he made an explicit contribution to promoting the image of the fantasist.

1891 — Invention of colour photography

1894 — The public are shocked by Aubrey Beardsley's picture of "Salome"; today it is seen as a precursor of Art Nouveau

1

"Reality is our own image of the world; it appears in every mirror, a phantom that only exists for ourselves, which comes, gesticulates and disappears with us."

Jorge Luis Borges

Finally it should be pointed out that the fantastic is present in almost all art and in almost every major art period, albeit in varying doses and with varying degrees of intent. With their strangely distorted perspective and the exaggerated proportions of certain bodily parts, the wild animals depicted in the 30,000-year-old cave paintings strike today's beholders as unnatural or alien, in other words fantastic, whatever mythical or cultic significance they may have had. The half-human, half-animal hybrids of ancient Egyptian art also come across as fantastic, as do the grotesque fetishes and fearsome totems of many "primitive" cultures.

Where would Baroque painting be without its infectious exaggerations, without the mannerist, the garish, the mad elements – the fantastic in other words? For Francisco de Goya (1746–1828) "capricho e invención" – fantasy and invention – formed the very foundations of art. Especially in his graphic works, the *Caprichos* and *Desastres de la guerra*, he succeeds in using chiaroscuro effects to express the nightmarish and the demonic. The fantastical has contributed to all significant art to a greater or lesser extent – in the past, certainly, and doubtless it will continue to do so. But our primary concern here is with the present.

Fantastic Art in the 20th century

In order to approach the fantastic art of the 20th century, it is necessary to bear in mind that it represents no more than an excerpt of an artistic whole whose components are interlocked. Unlike specific artistic trends and periods, which develop out of a particular era and after a while can be regarded as concluded, the fantastic has existed from the outset. It is a genuine component of all art in every age and in every place. Furthermore there are fantastic elements – in respect of both content and form – to be found in Mannerism, Symbolism, Surrealism, Dadaism and in other styles too.

In addition, it should be noted that the 20th century, the particular focus of our considerations here, witnessed no Fantastic trend, school, or common intent. With hindsight, from today's standpoint, such a tendency can however be discerned. So when we speak of various groupings, what we mean is that we characterize them as such from *today's* standpoint for the sake of better understanding.

The Fantastic was a significant trend in 20th-century art. It is often understood in contrast to conventional, established avant-garde art, although that is certainly inadequate as a criterion of characteriza-

1900 — Sigmund Freud's "On the Interpretation of Dreams" appears in the original German

1900 — World Exhibition in Paris 1901 — End of the Victorian Age with the death of Queen Victoria in England

2 3

tion. Or as Rainald Goetz puts it in his 1983 novel "Irre": "Nothing is so fantastically overwhelming as the authentic, nothing so incredible as real reality." In the visual arts too, the fantastic is more a particular manifestation of the real, and not its opposite.

The fantastic can also be found in other fields of art, such as literature, architecture, music and film; fantastical tendencies and currents can even be observed in the natural sciences, for example in the form of unusual, chance opinions and theories.

In the visual arts, the Fantastic shifted during the 20th century from the external to the internal, to the individual: the fantastical view of external phenomena – the world, nature, the cosmos – yields more and more to an introspective view of the person, the individual, the body, the self. Just as in the 19th century external reality could be explained with increasing clarity by the natural sciences – for example physics, chemistry, physiology and biology – and by mathematics, by the end of the 20th century the new science of psychology thought it had gained an equally novel insight into the inward man – the barely explored unending continent of the unconscious, of dreams, of emotions, and of desire. As a result, there suddenly opened up a new view of the Other, of others, and of one's own otherness. However, the possibilities of such an insight into the human self on the part of itself are subject to limitations where science is concerned. Art by contrast is subject to no such limitations.

The Fantastic contributes to the understanding and interpretation of the human soul; in the process, it has at all times evinced, and on occasion succumbed to, extreme manifestations. It has then run the risk of becoming fissiparous, droll, grotesque, weird, mannered, or even shallow and kitschy. On the other hand, the Fantastic can be understood as complementary to the rational, contructivist and analytical tendencies of the realistic, the abstract, the minimalist and the like; in short, of established art, or art as generally accepted.

In this mutual confrontation and adaptation, each side profits from the other. Ultimately the Fantastic, with its particular emphasis, its unbridled excesses and weird extravagances, reflects countless facets of the differential perception of reality. Expressed more poetically, the Fantastic, in all its manifestations, gives art colourful wings.

1907 — Pablo Picasso paints "Les Demoiselles d'Avignon" 1908 — Cubism is born
1909 — The first Futurist Manifesto appears, signalling the birth of Futurism

"The sleep of reason gives birth to monsters."

Francisco de Goya

4

The long history of the Fantastic

As already mentioned, elements of the Fantastic have characterized art from the very beginning. The earliest artistic objects and artefacts known often evince signs and shapes which transcend mere utility and thus probably can be related to something else. Thus the early stone sculpture known as the *Venus of Willendorf* (c. 25,000 BCE) surprises us not only through the excessive emphasis given to the female sexual characteristics, which identifies it as a fertility symbol, but also through the exaggeration of the expressive forms, which reveal it as an artistic object and also as fantastical.

When the bourgeoisie was coming into existence in the Netherlands in the 16th century, and the power balance between the church and state was being established, this balance was to all appearances reflected by life and art. It was at a time like this that a painter such as Hieronymus Bosch burst upon the scene to give expression to unconscious feelings in his drastic and incredible views of other worlds. The world of the bourgeoisie got out of kilter. Abysses threatened, fears appeared.

Or take the period immediately after the Second World War, when the political world was being cleanly carved up into East and West, good and evil, Abstract Art and Realistic Art: along comes a painter like Rudolf Hausner, denounced by the Nazis as degenerate, and tears up this rigid schematisation, this immobile world of either-or, with his extreme, multi-perspective paintings of himself.

If Sigmund Freud's *Oedipus* – the archetype of the boy in love with his mother and jealous of his father – was undisputedly the psychological protagonist at the start of this turbulent century, Hausner's *Adam* could be declared at its close to be the artistic shape of an individual absorbed in himself, the archetype of the modern *Narcissus absolutus*, who is fixated exclusively on himself, infatuated with his own reflection and looking at nothing else.

At the close of the 20th century, when it might have been believed that all the battles over an art of extremes had been fought, when for ideologies and art the motto was "anything goes", and when the politically opposed positions seemed to have been fought to a finish and even religious debate, incited by the polarizing pope John Paul II, could no longer arouse much passion – the Crucifixion scenes of the Chapman brothers from England and the depiction of the Pope by the Italian Maurizio Cattelan burst in upon the art world like a new kind of Act of God.

1910 — Wassily Kandinsky inaugurates abstract art with "Improvisation No. 10"

1912 — The allegedly unsinkable Titanic sinks after striking an iceberg on her maiden voyage 1914 — Outbreak of the Great War in Europe

"when reason sleeps, the sirens sing."

Max Ernst

Fantastical depictions in all ages serve as projection surfaces whenever a new order of things brings disorientation, and fear and doubt are the prevailing emotions. No wonder that fantastic visual art flourished particularly in the first half of the 20th century. In an age perceived as out of kilter and uncertain, fantastic art represents the projected grotesque silhouettes and garish colour fields of the immanent notions of disconcerted people.

The Fantastic in science

The Fantastic is that which is at home on the "fringes of reality" and for which no place can be found in any systematic classification. This happens in the everyday world, in the humanities, in the natural sciences and also in the field of the arts, such as literature, music, architecture and film. The visual arts have received a whole variety of impulses from these other spheres, and the same is true in the other direction. Neither can be appropriately explained or assessed without the other, in particular in the 20th century.

The 19th century was on the one hand the age of the great investigations, of breakthroughs, of scientific success: the world of the observable was explored, surveyed and explained. At the same time it was the age in which the esoteric, the strange, the inexplicable entered ever more strongly into public consciousness. Alongside the Enlightenment, it was the sinister, the inexplicable, the enigma, that began to show itself both in science and in everyday life. In addition to Gustav Theodor Fechner (1801–1887), one of the founding fathers of a new science, namely psychology, doctors and researchers such as Franz Anton Mesmer (1734–1815, the first parapsychologist, from whom we have the word "mesmerize"), Gotthilf Heinrich von Schubert (1780–1860, another proto-psychologist, and interpreter of dreams), Christian Friedrich Hahnemann (1755–1843, the father of homeopathy) or Rudolf Steiner (1861–1925, the founder of anthroposophy), produced their own concepts and carried out their own experiments in order to explain what was ultimately inexplicable. The scenarios employed to this end were in some cases futuristic and highly fantastical.

In the natural sciences in particular, the distinction between the empirical and the emotional, between the provable and the presumed, between measurement and intuition, is fundamental. Proof must rest on facts. But as a criterion in art, neither proofs nor facts have any role to play, nor could they. From the outset, art has employed other ways and means.

1916 — The Dada movement is born at the Cabaret Voltaire in Zurich 1919 — The Bauhaus is founded in Weimar

1922 — Establishment of the Union of Soviet Socialist Republics (USSR)

5. SALVADOR DALÍ

Portrait of Sigmund Freud –
Morphology of the Skull of Sigmund Freud
1938, illustration for "The Secret Life of Salvador
Dalí", pen-and-ink on paper, dimensions unknown
Chichester, The New Trebizond Foundation

6. FRIEDENSREICH HUNDERTWASSER/
JOSEF KRAWINA

Hundertwasser Building
1983–1986, Vienna, 3rd district,
corner of Löwengasse and Kegelgasse

7. ANTONI GAUDÍ

Sagrada Familia
1883–1926, Barcelona
Detail of the Nativity façade, completed under
Gaudí's supervision. The sculptures represent
scenes of the Nativity and childhood of Christ
(below) and the Annunciation (above).

6

7

Even so, the fantastical can play a major role in science. Via its own laws of imagination, investigation, demonstration and proof, it embodies the creative moment at which something succeeds, at which associations are suddenly recognized, and the solution to a problem becomes clear.

One example is Sigmund Freud, the founder of so-called psychoanalysis. His discovery of the human unconscious, the deep foundation of human behaviour and emotion, goes back to a particular scientific approach of this kind. It employs not only an empirically exact procedure, in other words one based strictly on experience, but also intuition, and above all unusual theories and assumptions which at the time were unthinkable, in other words fantastical. The exploration of the functioning of sexuality likewise goes back to this extraordinary and bold way of thinking on Freud's part. Since then, Freud has rightly been considered an important pioneer in the field of the psychology of art, which has never ceased to fall back upon the theses which he proposed.

The Fantastic in Literature, Music, Architecture and Film

Literature is full of fantastical poetry and other writing. Above all in the 19th century, which saw the transition between Romanticism, Classicism and Modernism, we find an abundance of novels and novellas with improbably fantastical contents. One only has to think of "The Devil's Elixir" by E. T. A. Hoffmann (1776–1822) or "Frankenstein" by Mary Shelley (1797–1851), of "The Raven" by Edgar Allan Poe (1809–1849) or "The Turn of the Screw" by Henry James (1843–1916).

Just as the Enlightenment was celebrating its first triumphs in science and the arts, and the raison d'être of human history was finding itself and culminating in progress of all kinds, there arose a counter-movement which sought to counteract precisely this "demystification of the world" – the expression coined by the sociologist Max Weber (1864–1920) to reflect the Industrial Revolution. Fantasy thus helped to create totally irrational times and spaces.

"The Other Side", a fantasy novel by the Austrian graphic artist Alfred Kubin, described such shadow and dream worlds. The novel wonderfully embodies some of the essential elements of the fantastic:

1924 — André Breton writes the "Surrealist Manifesto"
1925 — "Neue Sachlichkeit" presented at an exhibition in Stuttgart

"Fortunately, somewhere between chance and mystery lies imagination, the only thing that protects our freedom, despite the fact that people keep trying to reduce it or kill it off altogether."

Luis Buñuel

8

a city which is the product of imagination and illusion, a regime of dark authoritarian powers, people not of flesh and blood, but of intimation and mystery, strange events, a language of poetry and allusion and more besides, which, understood rationally, is virtually devoid of sense. The story betrays the nearness of the author to penetrating imagery, and the very title "The Other Side" reflects a specific reality of the consciousness of the 20th-century reader, a century at whose dawn Sigmund Freud's "The Interpretation of Dreams" (deliberately dated 1900) helped lay the psychological foundations of this development of the fantastic. The basic thesis of this work is that the limitless continent of the unconscious forms that space in a person's emotional life where fantasies multiply and can lead their unfathomably independent lives.

In music too, the opera "Salome" by Richard Strauss (1864–1949), for example, transports the abyssal aspect of the emotions, which at the time lay heavily in the Vienna air, into grand gestures and explosive drama. It is no longer death which is the intolerable mystery of life, but love: or at least that was the new and unfamiliar message. The music writhes free of all rigid rules, harmonies and rhythms, adapting itself to this new psychological zeitgeist. What had been added to the musical canon in the age of the classical symphony in

order to accord with a *harmonia mundi*, the harmony between the heavenly and earthly worlds that had been assumed for thousands of years, now turned to the human emotions, which, more than ever in this new "age of fear", needed aesthetic consolation in order to better cope with the new era and the new neuroses, or at least more sensitively.

Since the pioneering compositions of Richard Wagner (1813–1883) – the "Ring" cycle above all, in which Wagner used motifs from ancient Nordic mythology – music had become a leitmotif in the labyrinths and dungeons of the newly discovered ego.

Well over two thousand years ago, the Greek philosopher Plato (427–347 BCE) had emphasized the close connexion between music, mathematics and architecture. Fantastical architecture – which in turn can be discerned in numerous features of other styles – transcends the pure world of numbers, and often remains unbuilt: consider for example the still unfinished dreams of Antoni Gaudí (1852–1926) in the shape of the Sagrada Familia church in Barcelona, or the Expressionist designs of Erich Mendelsohn (1887–1953), whose Einstein Tower must be seen as a one-off, or the futuristic visions of Antonio Sant'Elia (1888–1916), none of which, quite literally, got off the drawing-board.

1925 — Re-founding of the "National Socialist German Workers' Party" by Adolf Hitler

1929 — Wall Street Crash is followed by world economic crisis

8. SALVADOR DALÍ

Un chien andalou
1929, still from film directed by Luis Buñuel

9. HR GIGER

Alien
1978, still from film directed by Ridley Scott

9

In film, the truly original art form of the period, the fantastical reached a new climax as the 20th century wore on. It allowed all existing fantasies to be consolidated, so to speak, and presented in a previously unimaginable form. Underpinned by the new insights derived from psycho-analysis, in particular the discovery of the human unconscious, the content of feature films, hitherto mostly a mere spectacle of mechanical sequences in the slapstick fashion, was able to assume psychological significance for the filmgoer.

Film is capable, alongside its entertainment function and potential, to create a fellow feeling for psychological problems. By identifying with someone else, cinemagoers are integrated into the action of the film. They become the heroes or heroines of their own drama, a circumstance which immeasurably extends the possibilities of fantasy.

Art forms other than film are hardly in any position to offer comparable conditions for effective fantasy. The new media which have evolved from film thus promise spectators (who are at the same time co-performers) new ways of seeing and perceiving in completely virtual space. Visual artists such as Salvador Dalí (in Luis Buñuel's "Un chien andalou" and Alfred Hitchcock's "Spellbound") or HR Giger (in Ridley Scott's "Alien") recognized these possibilities early on, taking an active interest in film and exploiting its potential for their art.

The vocabulary and psychology of the fantastic

The vocabulary of this field is fraught with ambiguity, not least because meanings are changing fast. The word "fantasy" derives from Greek and originally meant nothing more than "making visible", and hence, later, a mental image; and while a hundred years ago it might still have meant "whim" or "caprice" (or indeed the cognate "fancy"), modern dictionaries include phrases such as "unrestricted by reality" or "unobtainable desires" in the definition. A "fantast", or more often these days a "fantasist" (who used to be a harmless "creator of fantasies"), is often someone who confuses fantasy (in the more modern sense) with reality, and in particular, someone who boasts of non-existent feats. When we come to the adjective "fantastic" the situation is further muddied by the colloquial devaluation of the word to the status of a mere intensifier, although the alternative "fantastical" has avoided this fate. But at the root of the meaning of all these words are two notions: a "product of the imagination", on the one hand, and "untrammelled by the constraints of the real world" on the other. If we leave aside the pathological aspect, the gift of "fantasy", of creating the "fantastic" (in the sense of images unseen in the real world), is seen either

1936 — "Fantastic Art, Dada, Surrealism" exhibition at the Museum of Modern Art in New York
1937 — "Degenerate Art" exhibition opens at the Munich Haus der Kunst **1938 — State-sponsored anti-Jewish pogrom in Germany**

10. PARMIGIANINO
<u>Self-portrait in a Convex Mirror</u>
1523/24, oil on panel, diameter 24.4 cm
Vienna, Kunsthistorisches Museum

11. JOACHIM PATINIR
<u>Landscape with St Jerome</u>
1520, oil on panel, 74 x 91 cm
Madrid, Museo Nacional del Prado

10

as God-given, or as deriving from some higher, inner "intuition", a particular mental ability.

The "fantastic" in this sense is, from the point of view of content, usually associated with an explicit and implicit image of man; in other words, in its formal and pictorial language, it focuses in particular on the human being as a recognizable yet mysterious individual, subject to the caprices of nature, with his or her individual behaviour and actions, dreams, yearnings and unceasing desire. The "fantastic" is consequently much less a matter of art theory than of anthropology.

According to this view, the pictorial worlds of the "fantastic" focus not on the thing, the object, but rather on the subject, the individual human being, and the psyche. This also means that the fantastic sees itself as bound up with psychology, and in turn, that psychology has long since sought to explain how the fantastic functions – not just in art, not just in the artist, but in "normal" human beings in their role for example as beholders of art. Psychology assumes that the fantastic – seen as imagination, as a component of thought, of problem-solving, of creativity and of genius – has a role of its own to play in human behaviour, and particularly in perception, thinking and feeling.

Thus fantasy, in the sense of untrammelled imagination, is a mental activity and a psychological ability, a characteristic and an effect at the same time. It acts beyond the average mental activities, such as conscious perception, beyond predominantly logical "convergent" thought, beyond drawing conclusions in prescribed, ordered systems, and indeed beyond rational behaviour. The most striking features and characteristics of the fantastic thus include many-layered perceptions, emotional interpretations and a "divergent" mode of thought.

Many-layered Perception

Our perceptions of the world, including our perceptions of our own selves, may be consciously or unconsciously fantastical. As we mostly perceive and feel things which we can already categorize from experience, much information remains beneath the surface of consciousness. This is the sphere which, ever since Sigmund Freud, has been designated the unconscious. Now: art is usually perceived consciously and moves in the sphere of the familiar and the desired. Thus for example most people can understand Baroque painting because its symbolism, its relationship to space, and its technique are in accord with the modern canon of pictorial language and are familiar to modern beholders.

1939 — Germany invades Poland; outbreak of Second World War 1941 — The United States enters the war
1943 — First exhibition by Jackson Pollock at Peggy Guggenheim's Art of This Century gallery in New York

"The realm of legends is a strange universe which the world adds to itself without asking why, and without enlarging its scope. The realm of the fantastic by contrast reveals a scandal, a crevasse, a strange rupture, which would be intolerable in the real world … we must remember that the fantastic has no meaning in a world that is strange through and through. In a world of wonders, the extraordinary loses its power."

Roger Caillois, "L'image fantastique"

But when the Mannerist painter Parmigianino (1503–1540) produced his famous *Self-portrait in a Convex Mirror* in an unfamiliar manner that deviated from the expectations of the time with its particular optical arrangement, its visual distortion and strange content, the public were amazed. This sort of thing was unknown, even though anyone who had looked at him or herself in a convex mirror, for example a shiny teaspoon, must have had an inkling, but, and this is the point, no conscious awareness, of what such an image would look like. Parmigianino's self-portrait comes across as fantastical, in particular because it touches people's unconscious perceptions.

The fantastic addresses unconscious perceptions, albeit not only these. It plays with otherness, it amazes, it astonishes, it disconcerts. Imperceptibly and subtly, it directs itself towards previously known or hidden stimuli and sensations. Above all it plays with dreams, desires and yearnings: forms of behaviour which usually take place at a level hardly, if at all, accessible to our conscious awareness, and which precisely for this reason have a strong influence on behaviour. The fantastical represents for the unconscious what standard established art means for conscious behaviour, for understanding and for adaptation to reality.

Emotional interpretation

Everything we do, see and think is accompanied by emotions located in what is known as the limbic system on the medial surface of the temporal lobe of the brain, namely the olfactory cortex, the amygdala, and the hippocampus. These emotions constitute an important part of human development and without them we could not survive. Emotions such as fear, joy and grief help to regulate and stimulate our lives. All art, in particular fantastic art, has exploited these emotional elements. The reason we find the paintings of Hieronymus Bosch unsettling, to say the least, is the open and subliminal fear which everyone in the Christian West, as also, incidentally, in the Islamic and Buddhist worlds, is subject to as a result of religious instruction in guilt, atonement, heaven, hell, damnation and salvation.

The fantastical functions in a similar way where pleasurable sensations are concerned. When Arik Brauer paints pictures of one of the most terrible events in history, the Holocaust, he reminds us above all of atrocious and criminal deeds. But when, for this purpose, he uses colours of a very special poetic and graceful spectrum, he touches uplifting, joyful feelings. He does not do this in order thus to repress the horror, but, by taking advantage of pleasurable positive

1945 — Germany surrenders 1946 — The first European artists return from exile

1949 — Foundation of the two German states

12

12. RENÉ MAGRITTE
<u>The Blank Check (aka Carte Blanche)</u>
1965, oil on canvas, 81.3 x 65.1 cm
Washington, D.C., National Gallery of Art,
Collection of Mr. and Mrs. Paul Mellon

13. EDWARD BURNE-JONES
<u>The Baleful Head</u>
1885–1887, from the Perseus cycle,
oil on canvas, 155 x 133 cm
Stuttgart, Staatsgalerie Stuttgart

14. WILLIAM BLAKE
<u>God Judging Adam</u>
1795, etching with ink and watercolour
on paper, 43.2 x 53.5 cm
London, Tate Britain

"The imagination dissects the whole of creation according to laws that have their origin in the deepest depths of the soul, and then gathers and arranges the pieces, creating a new world from them."

Charles Baudelaire

sensations, which they feel when faced with the beauty of the picture, to make beholders receptive to the events and thus open to enlightenment and the learning process.

Beauty is a frequently misunderstood, occasionally overlooked, but essential feature of art. This central substance and characteristic of aesthetic perception and effect is founded on psycho-physiological processes of varying complexity which move, in other words motivate, the organism of the beholder to concern itself with the proffered contents, information and concerns in the first place. The fantastic picture also serves painter and beholder alike, in an emotional sense, as a surface for the attachment of metaphors, for psychological projections in the sense of defence mechanisms, and for yearning and desire. When the Flemish painter Joachim Patinir (c. 1485–1524) piles up his graceful rocky landscapes in the flat Netherlands to unnaturally high, fantastical formations in a many-dimensional space of sensation and dream, he thus unconsciously reflects in painting the fears of his compatriots in the face of the dangers of a new age which they perceived as threatening.

Deviant Thought

At the same time Patinir with his rocky landscapes arouses our curiosity in the enticing alienness – just like other fantastic artists at other periods of upheaval, for example the Belgian Symbolist Fernand Khnopff at the turn of the 20th century, the Belgian Surrealist René Magritte (1898–1967) and the founder of Pittura metafisica, Giorgio de Chirico, between the wars, the Viennese Fantastic Realists after the Second World War, HR Giger or Gottfried Helnwein in the late 20th century, and the brothers Jake and Dinos Chapman at the turn of the 21st century.

Psychology has shown us that we have to resolve contradictions in feeling and thinking in order to behave in an appropriate fashion. Deviations from expectations, knowledge and feelings at first create above all a raised level of excitement and attention. Artists have used this changed receptivity from the outset: above all, they want their art to be perceived, in order for it to be judged and valued. This holds true for the Fantasists in particular: they provoke an enhanced state of attention by deliberately displaying the unfamiliar and thereby incorporating contradictions. When Giorgio de Chirico displays the buildings of Italy to the beholder, he does this in the first place by

1955 — Warsaw Pact founded; West Germany joins NATO
1955 — The first "documenta" exhibition is held in Kassel in Germany 1956 — Pop Art is born in London

13 14

showing familiar views in saturated colours with a content of no great excitement. This is our first impression, in accordance with our usual degree of attentiveness as beholders. Suddenly, we notice that things are not as they should be: steep shadows, empty squares, silence. These perceptions start to disconcert our traditional convergent way of thinking and to trigger new, divergent patterns of thought. In this case, the fantastical provides the stimulus for expanding the behold-er's existing patterns of seeing in a complex, significant and disturbing fashion.

The Fantastical in the Visual Arts of the 20th century

As an intermediate conclusion, we can therefore say there has been no such thing as "Fantastic Art" in the sense of a specific art-historical genre or movement as such. Nevertheless, the presence of the fantastical can be demonstrated in almost every artistic tendency. The following sketch leads all the way through the chronology of the century and uses selected examples to bring out basic features in respect of content. In the process, certain characteristics will become apparent which link the various fantastic arts and artists, in spite of each of them being individual to the point of uniqueness.

interpretations of Dreams

Just as in the 19th century there had been the Nazarenes, the Pre-Raphaelites such as Edward Burne-Jones (1833–1898), the Symbolists and other groupings of artists whose painting ran contrary to the spirit of the age, so to around and after 1900 there were a number of artists who devoted themselves to a totally eccentric form of painting that cannot be assigned to any of the prevailing trends such as Impressionism, by then on its way out, or Cubism, then on its way in. The fantastical was, as it always has been, an artistic tendency that did not find itself in line with the standard styles of the day, and for that reason had at times to fight for recognition.

The turn-of-the-century fantastical touched not only upon the alien, the mysterious, the hidden, and the faerie, but also upon the incomprehensible, and sometimes upon religiosity, as earlier in the case of the English painter and poet William Blake (1757–1827), who used his art to propound a mystical world-view. Everything we cannot

1957 — In the USA federal troops force public schools to admit black children
1961 — John F. Kennedy becomes President of the USA 1963 — The Fluxus movement is born in Germany

15. JOHANN HEINRICH FÜSSLI

<u>The Nightmare</u>
1790/91, oil on canvas, 76.5 x 63.5 cm
Frankfurt, Goethe-Museum

16. MAX KLINGER

<u>Action</u>
1878–1881, plate 2 from "Paraphrase on
the Discovery of a Glove", washed Indian
ink and pen on paper, 22.2 x 19 cm
Hamburg, Hamburger Kunsthalle

17. FERNAND KHNOPFF

<u>I Lock My Door Upon Myself</u>
1891, oil on canvas, 72 x 140 cm
Munich, Neue Pinakothek

understand, everything we cannot grasp, either instils fear, or – as in the fantastic – inspires great feats of imagination. A picture by the Swiss-born artist Johann Heinrich Füssli (1741–1825), *The Nightmare*, captures the terror of sleep like no other. Füssli had known Blake since 1787, having finally settled in London in 1779, anglicising his name, and, as Henry Fuseli, becoming, in his adopted country, the most celebrated artist of his age. The fantastical spurred the artist to extraordinary things, and, like the extravagant imagery of Arnold Böcklin, Odilon Redon and Alfred Kubin, exercised a strange fascination on the beholder.

Sometimes the artists behaved eccentrically, not to say esoterically, by rejecting everything that did not accord with their own notions. This gave rise to a vicious circle of judgements and prejudices, of recognition and rejection, as a consequence of which the impression arose that these artists formed some sort of secret society. They thus came to imagine themselves to be in possession of a higher aesthetic truth, a notion which lacked any objective foundation. Elsewhere the fantastical was based on magic and myth, and on a subjective, personal "interpretation of dreams", which we can find in a particular form in the works of Henri Rousseau. At the same time this esoteric reference started to bring about developments of a very special kind within the horizon of the artists' perceptions of "self" and "other". In this way Fernand Khnopff and others, cutting themselves off, in their self-chosen isolation, from the art that was being produced elsewhere – as well known, Cubism and Expressionism were already surprising and fascinating the art world – were creating hitherto unheard-of or else forgotten worlds in their works, which formed a disconcerting contrast to the prevailing understanding of art.

In Munich, the former Academy student Franz von Stuck was among the founders of the Sezession movement, but in spite of this took a teaching post at the Academy in 1895. The leading French Symbolist Gustave Moreau (1826–1898) was also able to set himself up in opposition to the official taste of the Academy in Paris, and in his self-imposed isolation created a universe all of his own, filled with beguilingly alien portraits in which he re-interpreted mythological themes.

Max Klinger stuck out like a sore thumb in Leipzig, no less than did Gustav Klimt in Vienna, where the art scene was dominated by painters of historical pictures such as Hans Makart (1840–1884), who reflected the explosive economic expansion of the age with showpiece paintings that owed much to his Venetian role models

1967 — During anti-Shah demonstrations the student Benno Ohnesorg is shot dead in West Berlin 1967 — Birth of Arte Povera in Italy, and of Land Art in Europe and the USA 1972 — Arrest of the core members of the Baader-Meinhof terrorist group in Germany

"Even the unusual must have limits."

Franz Kafka

Titian and Veronese. Thus Klimt remained an outsider until he succeeded in getting certain influential personalities on his side. Much the same was true of Alfred Kubin, who, well off the beaten artistic track in the depths of provincial Austria, was living the life of a loner while working on a substantial oeuvre of mysterious drawings and paintings, some of which remain unseen to this day. Giorgio de Chirico, originally strongly influenced by Böcklin and Klinger, enjoyed a long artistic life, dying only in 1978, but already by 1910 he had created his most penetrating and inimitable views of the cities and public squares of Italy – presenting them as incomparable sites of mystery and dream.

The Roaring Twenties – Europe opens up

A new kind of artist now appeared on the scene, one that might be described as "exoteric" – in other words more open to outside influences. While modernism had hitherto been centred on Europe, artists from non-European countries now started introducing influences and ideas from exotic cultures. Wifredo Lam was born in Cuba, Sidney Nolan in Australia and Frida Kahlo came from Mexico. Also

to be included in this category are the Russian-born Peter Blume in the United States and, indirectly, the unusual painter Georgia O'Keeffe (1887–1986), who achieved celebrity not least through her depictions of enlarged details of flowers. To an astonished public, artists such as Pierre Roy and Paul Delvaux demonstrated with grand gestures and, for all their seclusion, considerable extroversion, what kind of surprises humanity had in store once we got off the beaten track.

Non-Western cultures were no longer perceived as being on different levels as they had formerly been, but came to be accepted and respected as equal but different. It was not only formal language that Cubism seemed to have shaken to its foundations and subjected to a new order, but also the exclusive faith in Europe. One constant of the fantastic is its trust in the universal, in common humanity, which, as a product of nature, does not essentially change over time: take for example, from a term coined by the art-historian and Max Ernst specialist Werner Spies, the "diabolical in the playful", which might be discerned in the early works of the Surrealist painter Joan Miró (1893–1983) and in Hans Bellmer's strange dolls. Even the meticulously listed and introverted – but for this reason all the more communicative – worlds of Pierre Roy fit into this category.

1977 — Opening of the Centre Pompidou in Paris with the "Paris – New York" exhibition
1978 — Camp David Accords between Egypt and Israel – Nobel Peace Prize for Anwar al-Sadat and Menachem Begin

18. GEORGIA O'KEEFFE

<u>Oriental Poppies</u>
1928, oil on canvas, 76 x 102 cm
Minneapolis, Frederick R. Weisman Art Museum

19. JOAN MIRÓ

<u>The Farmyard</u>
1921–22, oil on canvas, 123.8 x 141.3 cm
Washington, D.C., National Gallery of Art,
Gift of Mary Hemingway

18

In this group the period background, between the wars, also plays a decisive role. Traditional values had lost their normative character, the new was on the march everywhere, and the fantastic was losing its fairy-tale decorative innocence and seeing itself forced to reveal its painful, incomprehensible, repellent and brutal sides. The new contents and forms of fantastic art were being dictated vociferously and impetuously by the likes of Richard Oelze and Rudolf Schlichter. While Salvador Dalí at the core of this group represented the most charismatic and extraordinary type of fantast, the Argentine-born Leonor Fini should be mentioned as typifying its most subtle and esoteric manifestation.

The second world war as a caesura

After the disaster of the Second World War, we can perceive a diminution, a moderation, indeed an aesthetic camouflage of artistic intensity. Unlike the Viennese Fantastic Realists, who exaggerated the language and content of their pictures, overloading them with significance and symbolism – and who form a chapter of their own – a group one might refer to as sublime fantasists exercised extreme reticence, which, together with their elegance and subtlety, was the trademark of their art, except that they would have distanced themselves from any such epithets. The movement is characterized first and foremost by ambivalence and ambiguity, and, as the pictures of Balthus and Andrew Wyeth demonstrate, is beyond the reach of definition.

The artists were all more or less loners, who avoided publicity and lived as recluses mostly somewhere in the country, well away from large cities and other manifestations of civilization, or else commuted between continents, like the jovial, yet reticent Fernando Botero. They worked in silence like Werner Tübke, not trying to attract publicity through scandal – a well-worn method in the art scene – and were thus for media-oriented critics not really worthy of mention. Instead, their aesthetic intentions were directed inwards, their pictures being highly charged with subtle, iridescent meanings.

Dorothea Tanning captivates beholders with strange compositions involving people and space; Fabrizio Clerici, a painter still really waiting to be discovered, fascinates us with his imaginary views of ruinous townscapes: pictorial contents, in other words, which put themselves across beneath the threshold of attention, of consciousness and of comprehension. The aesthetic substance of the pictures

1979 — First sensational successes for the "Neue Wilde" (neo-Fauves) in Germany 1980 — Start of the Gulf War between Iran and Iraq
1981 — Contemporary German art on display at the Musée d'Art Moderne de la Ville de Paris

20

"The wonderful thing about the fantastic is that the fantastic does not exist: everything is real."

André Breton

is well-considered, executed with attention to detail and carries conviction by dint of an aura which is slow to dissipate.

The vienna school of Fantastic Realism

The painters of the Vienna school of "Fantastic Realism" form one of the few groupings of individual artists, who, largely through being thus characterized by outsiders, constituted a so-called movement, while at the same time never existing as an organized group. We owe the term "Wiener Schule des phantastischen Realismus", usually translated as "Vienna School of Fantastic Realism", to the Viennese art critic Johann Muschik. In this sense it is no more than a label which hides more than it reveals. Even so, it shone the spotlight of international publicity on to a number of artists of approximately the same age, who had studied in Vienna, and who in most cases were working on their own.

The term "Realism", whether or not in combination with "Fantastic", hits the nail on the head where their works are concerned, for they created an art which is ultimately anchored deep in their own experience. These Fantastic Realists painted quite literally for their own sur-

vival. Thus Ernst Fuchs and Arik Brauer (b. 1929) had already as children had to fight for their lives because the perverted racial logic of the Nazis classified them as Jews on account of their ancestry, while Rudolf Hausner and Anton Lehmden (b. 1929) had to assert themselves in the face of war, deprivation and suffering.

Their fantasy visions are thus a kind of defiance, a use of extreme means to position themselves vis-à-vis the precarious reality of the time. The fact that the fantastical, in the case of Brauer and Lehmden, for example, presents itself in the guise of the colourful, the beautiful, the fairy-tale, the organic – and thus enchants rather than disturbs the beholder – is what gives these two artists their special charm. A typical painting, for example, is Brauer's *My Father in Winter* (1983): curiously dreamy and with the beauty of a fairy-tale, executed in fine pen-strokes; a figure from the individual imagination, exuding inner tranquillity. That is, until the beholder becomes aware of a particular detail which seriously disturbs this tranquillity: attached to the left-hand side of the figure's breast is a yellow star, which comes across almost as a luxuriant yellow flower. The Star of David shakes our previous impressions, stimulating new interpretations: the idyllic "winter journey" is not Schubert's melancholy, idyllic dream, but a fate that cannot actually be given any aesthetic gloss.

1982 — Video-exhibition at the Whitney Museum of American Art in New York 1986 — Nuclear reactor disaster at Chernobyl in the Ukraine
1987 — Arms deal between Ronald Reagan and Mikhail Gorbachev 1989 — The Berlin Wall comes down

"A theory of the fantastic which could distinguish the real thing from the fake would be of great cultural benefit today."

Stanislaw Lem

20 21

Above all, though, these "fantastic realists" found and developed a new unmistakable and stimulating pictorial language of their own. The fantasies which they dug up from the depths of humanity's darkest abysses, where myth and the archetypal meet with no frills, become with Rudolf Hausner psychological, with Ernst Fuchs mythic-religious, with Arik Brauer fairytale-graceful, with Anton Lehmden microscopically natural, and with Wolfgang Hutter sensuously captivating colourful shapes. With their strange contents, which present sights hitherto unseen except in their own mind's eye, these artists contribute a chapter of their own to the story of fantastic art, a chapter of unusual visions.

Although they played a pioneering role in the context of post-war art in Austria, and succeeded in celebrating veritable triumphs in the art market, the echo of their paintings has in the meantime subsided. Their immediate influence on art was limited to their own times, even though they founded a school of their own both within and outside the academies, a school from which many students have since graduated. However, and therein lies their real importance, these painters – like their great teacher at Vienna's Akademie der bildenden Künste Albert Paris Gütersloh (Albert Konrad Kiehtreiber, 1887–1973): in turn a pupil of Gustav Klimt, a friend of Egon

Schiele and himself also a significant poet and author – put Austria on the international visual-arts map in a way that it had not been previously.

The turn of the millennium – a new cardinal era?

By the end of the millennium, "good taste" had had its day, and after three thousand years of art history, so had any remnant of consensus. Among fantastical artists, the emphasis was once more on the garish, the loud, the direct, not to mention on occasion the ugly. For these artists, there is nothing sublime in our miserable lives, nothing beautiful in the impenetrable forest of art: they can be thought of as extreme. Like for example Gottfried Helnwein (b. 1948), they put their opinions on the line with no attempt to soften them, deliberately demonstrating terrifying insights into the perversities and excesses of a world perceived as crumbling. Helnwein's portrayals of children form a genre in their own right, one which disturbs our perception in a fundamental manner. Since his series of disturbed, maimed, humiliated, wounded and abused children – for example *Child* dating from

1990 — The Soviet Union disintegrates; Slovenia, Croatia and Bosnia-Herzegovina secede from Yugoslavia

1990 — East and West Germany unite

20. ARIK BRAUER

My Father in Winter
1983, oil on cardboard, 107 x 98 cm
Vienna, Arik Brauer collection

21. ANTON LEHMDEN

Hovering Jewels
1951/52, oil on hardboard, 48.5 x 27.3 cm
Vienna, Peter Infeld Privatstiftung

22. ALBERT PARIS GÜTERSLOH

A Little Night Music
1938, gouache, 15.56 x 21 cm
Vienna, Graphische Sammlung Albertina

22

1991 – the world of childhood has no longer been what it once was. But: was it ever what it seemed? In the course of human history, was childhood often not a period of brutality and cruelty? Is our oversensitive view not a fantasy in itself? And is the childish-innocence notion not merely a romantic construction of a questionable biologism?

At the same time, HR Giger has taken the extreme to further paradoxical extremes by using a classically restrained manner to fill chaotic depths with monsters and depicting them as quasi-moving images, as on film, of horror scenarios. Giger pushes beholders unrelentingly towards pictures they never wanted to see and which will never let them go, pictures that will constantly prey on their emotions for ever after.

These deliberate provocations, breaches of taboo and overstepping of boundaries, test the pain threshold of a public who actually by now should have been inured by the mass media to find nothing shocking, perverted or otherwise atrocious any more.

Thus this trend in fantastical art, beyond all aesthetic, let alone moral, judgements, can be seen as a kind of cunning, necessary corrective for an uncontrolled art scene and society in which more or less anything goes. It seeks to explore how far one can go, how much one can show, and how grossly a picture can be distorted; in short, how much one can expect of the beholder. Perhaps the art of those naughty Chapman boys or that bogeyman of polite society Maurizio Cattelan can at least cause a few questions to be asked, if not hold an ironically misted mirror up to a media-saturated public.

The Global Dimension of the Fantastic

By the year 2000, it was possible to observe a change in, and a further dissemination of, the fantastic, which was undergoing mutations into wholly different forms and contents, as in the paintings of Peter Doig or the incomparably condensed photography of Jeff Wall (b. 1946), and becoming increasingly familiar beyond Europe too, in the process often undergoing a change of medium from painting (the traditional technique of the fantastical) to sculpture, to happenings, and to the virtual worlds of cyberspace. Virtuality, in itself already a form of fantasy, allows the fantastical to be received worldwide. Alongside the familiar mystic, mythic, magic and illusionist themes, everyday, realistic and hyper-realistic pictorial worlds, stretching into the realm of science fiction, are now being taken into the repertoire.

1995 — After years of trying, the artist couple Christo & Jeanne-Claude wrap the Reichstag building in Berlin
1998 — Economic crises in Asia and Russia shake the world's stock markets

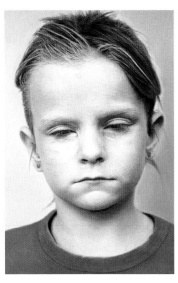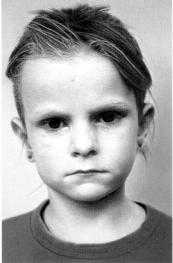

23

23. GOTTFRIED HELNWEIN

Child I + II
1991, oil, acrylic on canvas, diptych, each panel
210 x 140 cm
Klosterneuburg, Sammlung Essl

24. JEFF WALL

The Giant
1992, transparency in fluorescent light display case,
49.5 x 58.4 x 12 cm
Private collection

25. GUO JIN

Leap
1995, oil on canvas, 190 x 155 cm
Bonn, Private collection

Furthermore, cultures which have hitherto preferred other contents for their visual arts, such as China, Japan and Indonesia, are now taking an interest in the fantastical, finding in it astonishingly novel and independent possibilities of expression. In their aesthetic quest for form and content, artists from these Far Eastern countries are reaching conclusions fundamentally different from those of their Western counterparts. This can be observed most obviously in China. Here, where for millennia brush-and-ink painting has developed its symbolic pictorial language in endless variations over the millennia as different political regimes have come and gone, visual artists have suddenly demonstrated a predilection for a whole variety of fantastical images. Maybe one of the reasons is that this of all countries, whose culture after all consists literally in rules and rituals, and whose language is constituted by an artistic composition of picture, sound and meaning, has clung hitherto so rigidly to prescribed tradition.

The turn of the millennium has now been accompanied by the sudden crumbling of this rigid structure: hence all the greater is the desire for the new and the different. The painter Zhang Xiaogang is the first to integrate the Western-style fantastical into his pictures, and, in common with other artists in this context, is using these stylistic means – ironically, sarcastically and critically – to develop a totally new form of expression, which has been practically unknown in China hitherto. The old pictorial world is being violently and pleasurably smashed, its set-pieces being playfully re-assembled into new views. This is also the case with the Chinese artist Guo Jin (b. 1964), who once more celebrates dolls in his paintings, in the form of highly individual puppet-like figures.

Thus the new fascination with oil-painting in China is making use of many of the contents and techniques of the long tradition of fantasies and phantasmagoria of Old Europe. Doubtless this will be the fount in the future of a whole variety of totally unaccustomed, unseen fantastical perspectives. As far as fantastic art is concerned, globalization seems to have succeeded already.

Fantastic Art – Timeless

Although Fantastic Art has a long history behind it and has experienced a heyday in the modern age – in particular at the start of the 20th century – there is ultimately no end in view. It is precisely the fantastical element in the visual arts which has shown itself to be so flexible when it comes to genre crossovers. It represents

2000 — At the turn of the millennium, the world's population is more than 6 billion: Two-thirds have never used a telephone, 40 % have no electricity, one-third live as nomads below the subsistence level

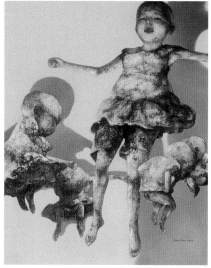

an open, self-organizing system, which is able to adapt to new fields and circumstances and thus to mutate into something different. It is able to unfold the dynamic in art, bring it to full blossom, and keep it moving, even if in the process it allows some questionable kitsch to flourish in the mire. The fantastical is constantly probing reality for something new and unfamiliar, and having found it, seeks to make it visible.

In all ages, the fantastical has told of the sublime interstices of the human soul, and also of its secrets, its depths and abysses. It dares to step through the looking-glass, it devotes itself to the areas which lie between the orders, systems, categorizations, and beyond the known, the familiar, the average and the calculated. In this respect, Fantastic Art is – in contrast to some other art, such as the various -isms, caught up in the fashion of the times which brought them forth – open, boundless and unfathomable. It is timeless, it has a future, and not least because Fantastic Art is geared essentially to the human being: to the human body, to human behaviour, to human actions, to human consciousness, to the human unconscious, and to the sunny side and the dark side of humanity.

The mystery of mankind in all its riddles, contradictions and uniqueness in the midst of creation was, is, and ever shall be the pre-ferred object of desire in Fantastic Art. Not least it is this that explains its long tradition and its unbroken fascination. The fantastical is an integral and genuine component of every kind of art, which it has accompanied in all its varied manifestations throughout history, from the beginning to the end.

2001 — Islamic terrorists fly two airliners into the New York World Trade Center, destroying the twin towers with the loss of some 3,000 lives
2003 — The USA start the war to topple Iraqi dictator Saddam Hussein by bombing Baghdad

тhe ısland of the рead

Varnished tempera on canvas, 111 x 155 cm
Basel, Kunstmuseum Basel

**b. 1827 in Basel (Switzerland),
d. 1901 in Fiesole (Italy)**

The picture which can best lead the procession of the fantastic art of the 20th century is Arnold Böcklin's *Island of the Dead (Die Toteninsel)*, first painted in 1880. It is seen as *the* icon of fantastic art: the swan-song of the Romantic art of the 19th-century, while at the same time providing a prophetic preview of the fantastic art which was to flourish in the 20th. As a prototype with a unique vision of the past and the future, it is a "very German painting". A contributory factor in this assessment is perhaps also the unfortunate fact that the third of the total of five versions executed by the painter was in the possession of Adolf Hitler, and was displayed in the Reich Chancellery.

And yet it all began in a rather unspectacular fashion: a lady from Frankfurt merely commissioned a "picture to dream to" from Böcklin, who, although by no means famous, had by that time already established himself as a painter, owing his artistic breakthrough to such idyllic pictures as *Pan in the Reeds* (1858). But what neither she nor the artist could possibly have foreseen very soon came true, and *The Island of the Dead* became the "picture to dream to" par excellence, both in the positive and in the negative sense.

An islet glows in the golden rays of the setting sun. It consists of lofty towering cliffs, which enclose and protect a dark grove of cypresses. Against the cliffs we see smooth, shining white marble walls, which resemble burial chambers, adits to a subterranean world of the dead, from which, as is well known, there is no return. On the calm, almost mirror-like surface of the sea, there approaches a small boat, rowed by a figure shrouded in a dark-red cloth. Behind this sinister figure, already facing towards the island and away from the beholder, and hence unidentifiable, we see a person clad in white standing in front of a sarcophagus covered in pale cloth. The spellbound silence of the eerie nocturnal event which is about to take place is almost palpable.

Böcklin's "picture to dream to" accords with a fundamental element of the fantastical, which by 1900 with its various motifs was seeking access to the deeper origins of the psyche and in particular the dream and its interpretation. 1900 saw the appearance of Sigmund Freud's book on "The Interpretation of Dreams", one of the standard works of what was then the young science of psychology. It treats the dream as a metaphor for all the areas of the unconscious, those repressed memories deep within us which are barely accessible to us, if at all. *The Island of the Dead* is the perfect embodiment of this: it is a place of the unreal, of the mysterious, of the nocturnally dark, of the final, a place not only of eternal longing and of people's desire but also the final stop on their life's journey. In his picture, Böcklin has given incomparable expression to this place, and thus made it into an icon, which artists still to this day quote, or caricature, in countless variations.

The deeper fascination triggered by this picture derives on the one hand from the strange placelessness of the activity depicted, and on the other from its ambivalence of form and content. This island will be sought in vain, even though it is both realistically painted and based on Ermenonville, conceived as the ideal place by the French philosopher Jean-Jacques Rousseau (1712–1778). It embodies an emotional idea, a desire, a phantasm. This shadow world is bathed in the wan light of the uncertain. Everything comes across as both clear and befogged, both bright and dark, as real as it is eerie. Nothing here is what it might seem. The moment one seeks to pin it down, or to interpret it, it dissolves into nothing.

> **"вöcklin's metaphysical power always derives from the precision and definition of a predetermined phenomenon. … еvery one of his works generates the same shock, which shakes us out of our composure."**
>
> **Giorgio de Chirico**

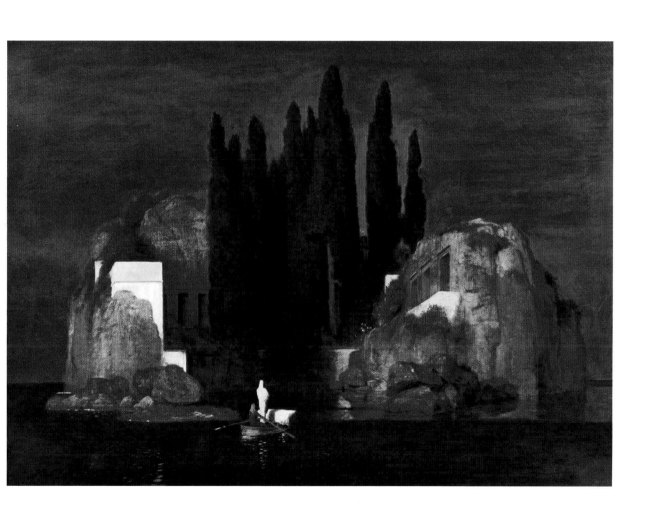

тhe sin

Oil on canvas, 94.5 x 59.5 cm
Munich, Bayerische Staatsgemäldesammlungen

**b. 1863 in Tettenweis (Germany),
d. 1928 in Munich**

This picture by Franz von Stuck is one big challenge, or at least it was in its day. That we hardly get worked up about it today is due to the changed artistic and moral imperatives of our age. What catches the eye nowadays is rather, for German-speakers at least, the title of the picture, idiosyncratically spelt, carved conspicuously into the specially made frame: *The Sin (Die Suende)*. The unusual is not confined to the frame, though; the picture itself depicts a lecherously half-naked woman, giving us a come-hither look from the semi-darkness, her moon-pale body in the coil of a large snake. This is one of Stuck's successes: between 1891 and 1912, he painted numerous versions of this theme.

At this time Stuck, who had worked his way up from very simple beginnings, was achieving major recognition, both artistically and socially. In 1892 he was one of the founders of the Munich Sezession, in 1895 he was appointed professor at the Munich Academy, where his pupils included Josef Albers, Wassily Kandinsky and Paul Klee, and in 1906 he was ennobled (hence the "von" in his name in later years).

Visual perception can give rise to a high degree of satisfaction as a result of a wide variety of stimuli, including, not least, erotic allusions. These "sexual perversions", as science classified them at the time, were put on a level with sadism, masochism and fetishism. From the point of view of content, Stuck's *Sin* is related to Leopold von Sacher-Masoch's "Venus in Furs". Viewed aesthetically, however, there is more to the picture: the convincing composition of fascinating mystery and a fantastical digression into the no-man's-land between what can be said or shown and the unmentionable or taboo. But this tightrope act is an integral component of painting generally. What can be shown without giving offence? To what extent, in fact, must significant art give offence?

Stuck has given expression to these questions in his picture, whose significance lies between mystery and the truth open to painting, in suggestion, and in the confident mastery of revelation and concealment. It plays a skilful game with the set-pieces of pleasure-in-looking: with this picture, the artist ministers to the overt or covert voyeurism of his clientele in particular and ultimately of all beholders of art in general. The scopophilia, or "love of gazing", which Sigmund Freud identified as a part of the human psychological apparatus, relates not just to looking at forbidden things and pictures, but also represents one of the basic human needs, in common with curiosity, visual discovery and exploratory recognition.

> "тhe fame of the picture drove us through the galleries; we wasted no time anywhere else; only when we at last stood in front of it did we open our eyes. ıt was displayed on a special easel in its monumental broad gold frame, surrounded by a semicircle of curious onlookers … тhere are works of art which enhance our sense of community, and others which entice us back into our individual shell; this painting by stuck is one of the latter. тhe figure pointed each beholder down a lonely road, where sooner or later he would be bound to meet one of her living sisters."

Hans Carossa, "The Year of Sweet Illusions", 1941

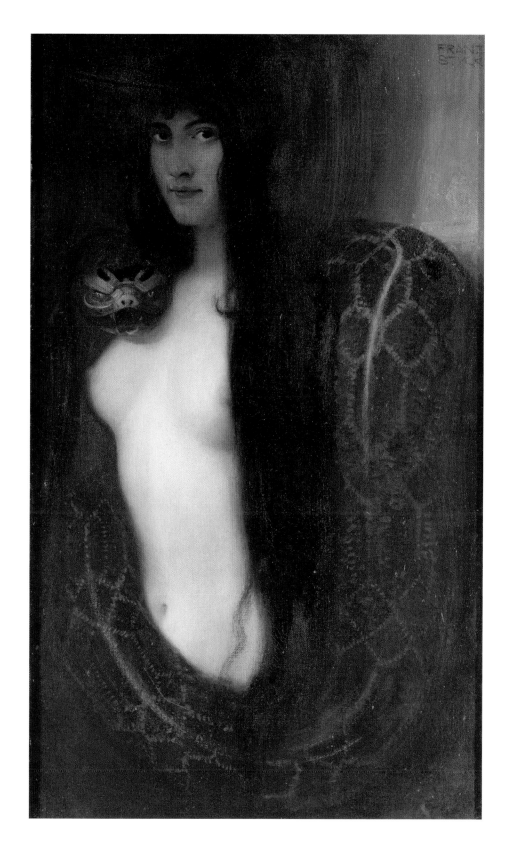

self-portrait with masks

Oil on canvas, 117 x 82 cm
Private collection

**b. 1860 in Ostend (Belgium),
d. 1949 in Ostend**

The pictures of James Ensor, who was initially regarded with scorn or total lack of understanding, had to wait a long while to be appropriately interpreted and appreciated, for they were far ahead of their time. In particular, it is the events of the era of Fascism and National Socialism in Europe that have caused beholders to view his pictures in a different light. Thus the estimation of Ensor has changed from viewing his role as that of an eccentric loner to that of a unique and fantastical visionary. The son of an English engineer and a Belgian souvenir dealer, he studied at the Académie des Beaux-Arts in Brussels from 1877 to 1879. A recluse, he attained official celebrity at a relatively late stage. In 1899 the Albertina in Vienna bought a hundred of his works. In 1901 his hometown acquired a series of 118 etchings, and finally in 1930 he was ennobled.

Colourful masks – his studio was full of them – were a constant feature in Ensor's thespian-droll imagery. His pictures with the masks provide a premonition of the end-games of the modern era: after all, is not the mask the means used by Ancient Greek theatre to de-individualize an actor and to replace him with a "persona", through which only his voice penetrates?

Ensor's self-portrait in Baroque pose, *Self-portrait with Masks (Ensor aux masques)* was painted at the climax of his creative period; it was influenced by the self-portrait by the great Antwerp painter Peter Paul Rubens. The painter is surrounded by masks, though his own face – whether naively or by design – is uncovered for all to see. Ensor is almost crushed by the masked figures, whose bloodless faces and painted lips embody the artist's obsessions, namely with being crushed by the mass, with the human abysses behind the beautiful.

Ensor's very specific coloration underlines the visualization of a latent danger: the fresh, rosy flesh suddenly comes across as raw.

With a fine pen and a palette of glossy transparent paints, including some garishly poisonous hues, he turns all the masked figures into an unpredictable threat.

The comic aspect of the scene thus imperceptibly keels over into a deadly game with assigned roles: in the midst of a crowd determined to do anything, even if, like here, it is only a large-scale grimace, the individual has no choice but to flee. In Ensor's picture, while the individual is offered up to the mocking laughter of the horde, he is at the same time fitted out with the protective insignia of the normal citizen, which allow him to escape. The bourgeois world is grotesque, its abyssal depths concealed behind masks, but by that very fact capable of being displayed. That Ensor was able to register this so clear-sightedly in his inconspicuous lifestyle between the wars, and implement it in great painting, is what secures his status as a visionary of the fantastic.

Death Pursuing a Flock of Mortals, 1896

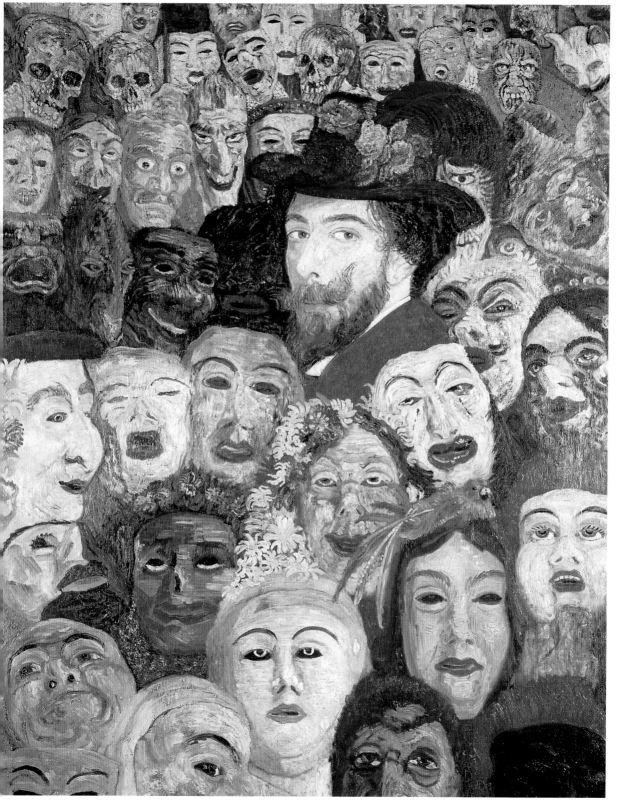

Beethoven

Greek marble; drape: onyx; plinth: Pyrenean marble; eagle's eyes: amber; eagle's claws: bronze; throne: bronze; heads: ivory; mosaic stripes: glass, agate, jasper, mother-of-pearl, gold leaf, 310 cm overall height
Leipzig, Museum der bildenden Künste

b. 1857 in Leipzig (Germany),
d. 1920 in Grossjena

The sculpture by Max Klinger of *Beethoven* enthroned like an emperor ushered in the new century majestically and in eye-catching fashion, as if accompanied by a roll of drums and a blast of trumpets. At the same time it comes across as self-assured, proud, unapproachable, awesome, heroic and superhuman in the sense of the philosopher Friedrich Nietzsche. The whole sculpture is a massive and yet finely worked conglomerate of marble, onyx, bronze, semi-precious stones and ivory, a monument in which everything has to be of the finest and most noble materials and workmanship. The sculpture was appropriately exhibited and presented in 1902 at the Vienna Sezession building, created by the Art Nouveau architect Joseph Maria Olbrich for the new century and for the equally new art which this new century was bringing forth. This exhibition, which was conceived as a homage to the composer, was the most splendid manifestation of the Sezessionist "gesamtkunstwerk" idea: under the management of Josef Hoffmann, a total of 21 artists contributed; Klinger's *Beethoven* was placed in the centre. The galleries were decorated by Gustav Klimt's *Beethoven Frieze*, which is on view in the Sezession building to this day, albeit in a different context.

Klinger's monument lives by its sheer exaggeration, and by the pose – the unmistakable characteristics of the fantastical. Klinger takes recourse to well-known anecdotes concerning the genius, while at the same time, his interpretation was to influence the regard in which the composer continued to be held as the 20th century progressed. The sculptor depicts Beethoven as an Olympian deity: if only by dint of the naked upper body, he alludes to portrayals of gods handed down from Antiquity. His *Beethoven* juts his chin forward, firmly resolved to undertake any task; he is surrounded by the insignia of heavenly and earthly powers: angels, eagle, rock and throne. All in all, this supra-fantastical sculpture is also the unmistakable expression of an unbounded pride in the great son of the nation. Only years afterwards was Klinger able to sell the sculpture, which he had produced at his own expense, to his home city of Leipzig.

Even though our own age has a more reticent attitude to the cult of the genius, the immanent pathos to which this sculpture points is still both moving and convincing. For Klinger is also making the extraordinarily difficult attempt to find a solid, material and monumental expression for music itself, that most fleeting and immaterial of all the arts. That the sculptor in the process chooses to do this via the person of a composer is determined by the nature and tradition of sculpture. After all, the visual arts are what they are precisely because they literally embody and thus give visible expression to the ineffable, the mere idea, the "in-between".

Klinger was a versatile artist whose virtuoso technique as a painter and particularly as an engraver gave form to his fantasy-rich world of the imagination: he wanted nothing less than to recreate the colourful sculpture of Antiquity. But his *Beethoven* also shows that the fantastical can sometimes succumb to self-indulgence, or even caricature. It does this when it oversteps too far the bounds which – in spite of its inherent boundlessness – finally are there. That this *Beethoven* does not fail in the end for this reason is ultimately due to the greatness and the magnificence of the attempt itself.

> "klinger was the modern artist. modern not in the sense which is given to the word nowadays, but in the sense of a conscientious man, who, aware of a centuries-old artistic and intellectual heritage, looks into the past, into the present and into himself with a wakeful eye."
>
> **Giorgio de Chirico**

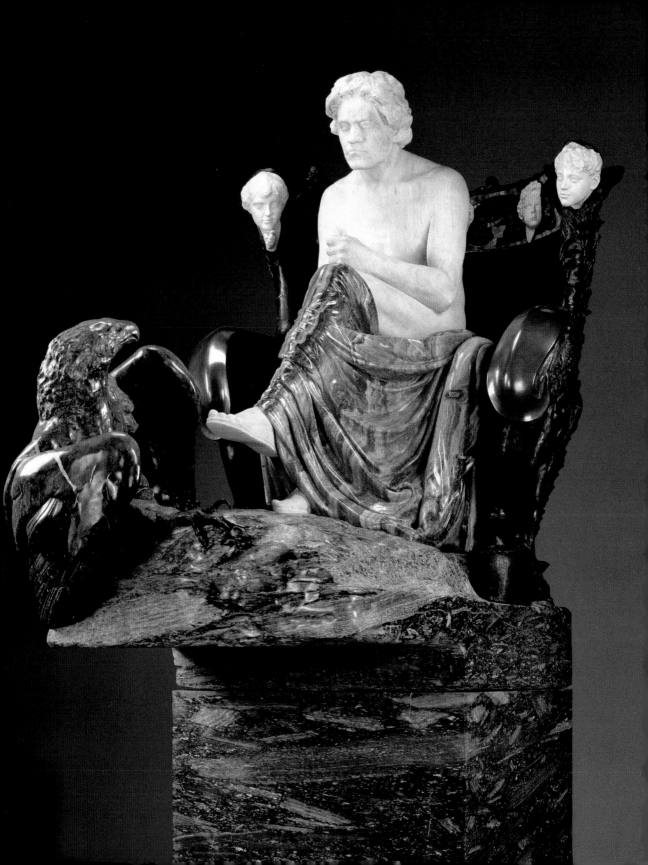

snake god

Pen, Indian ink and watercolour, sprayed on cardboard, 20.8 x 21.2 cm
Linz, Oberösterreichisches Landesmuseum

b. 1877 in Litomerice (Austro-Hungary, now Czech Republic), d. 1959 in Zwickledt (Austria)

Alfred Kubin is a fantastical artist who on the one hand is highly appreciated and much collected in specialist circles, while remaining almost unknown to a broader public on the other. His retreating to a rural fastness on the border between Austria and Bavaria, while contributing to his unfamiliarity, has also enhanced his aura. His predilection for graphic works, in particular small-scale graphic works, fits into this image. He created thousands of pen-and-ink drawings, in which he conjured up macabre visions of dissolution and of a fantastical world.

The technique of these drawings by Kubin is unsurpassed, individual, innovative and at the pinnacle of its age. It is true that the contents, although mythological, esoteric and weird, have their origins in the usual concerns and goals of his fellow-artists in the age of the two great wars, of upheavals, and of crises; in Kubin's case, however, they are raised to an inimitable level of fantasy. In his work, the collapse of the Austro-Hungarian monarchy is depicted no less subtly and bitingly than, with foresight, the new demons represented by the political seducers waiting in the wings.

Kubin's *Snake God (Schlangengott)* is just such a figure, reflecting not only the end of something indefinitely diffuse, but also proclaiming the prophetic signals of the impending catastrophe. When the snake god goes on his travels, then there seem to be hefty rumblings in the nether regions, his mythical ancestral home: the signals are those of danger. In an almost playfully graceful, elegant manner, a being with the upper body of a man, a somewhat disproportionately large skull upon which is perched some undefined headgear suggestive of authority, and a long reptilian tail, writhes towards the beholder. Its two arms are spread out, while the claw-like hands are raised threateningly into the air, demanding attention.

This baleful creature, whose body is barely raised above a rocky cliff which falls away precipitously to the side, presents itself as a being that seems not quite to have its origins in the familiar plan of creation; rather, this creeping minatory figure is suggestive of a lord of the underworld, a ruler from the realm of darkness. Indicators of this are the dark colours and above all the numerous intermediate greys.

Since time immemorial, the snake has been considered in the myths of numerous cultures as a bringer of woe. This is not, as one might first imagine, because some of the venomous species can indeed be deadly, but rather because of its habitat, writhing in the dust, and its soundless creeping movements, which human beings have always found disconcerting. There are good reasons therefore for viewing Kubin's *Snake God* too – with hindsight – as a baleful creature of this kind, anticipating the apocalyptic events in Germany and the world thirty years later.

Many of Kubin's works on paper bear the signs of this prophetic gift, hinting at the destruction, terror and killing to come. Like his pictures, his fantasy novel "The Other Side" (1908) is permeated by a world of dark thoughts. It tells the story of a graphic artist who is invited into a so-called dream realm, where he whiles away a dull existence in a world beneath dark clouds. In his fantastical-demonic style, Kubin unites personal experiences, visions and tormenting nightmares.

> "In the decline of the bourgeois world in which we participate as actors and sufferers, Kubin sees the signs of an organic destruction which has its effect at a more subtle and fundamental level. He depicts a chronicle whose sources are to be seen in the cobwebs, the creaking of the woodwork, and the cracks in the masonry."
>
> Ernst Jünger

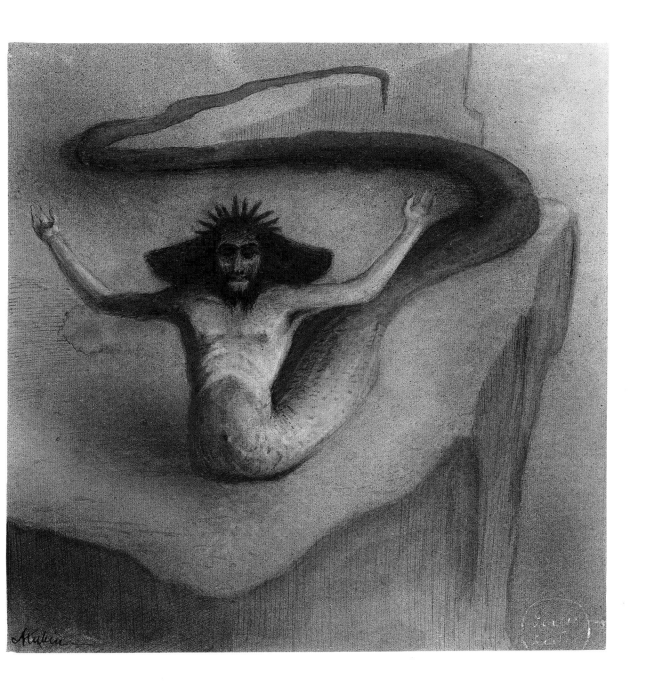

тruth II

Oil on canvas, 207 x 293 cm
Zurich, Kunsthaus Zürich

**b. 1853 in Bern (Switzerland),
d. 1918 in Geneva**

Like Max Klinger and Franz von Stuck, the Swiss painter Ferdinand Hodler stands in the tradition of a fantastical art which comes across as, if anything, "heroic". In Hodler's case too, the dominant feature is the sweeping gesture, which always seems to point away from and beyond itself. The decisive feature is his strict re-nunciation of realism in favour of symbolism. It was only in his late work that he moved away from this tendency towards a modern "art of the soul", under the influence of the Norwegian painter Edvard Munch, with whom he exhibited in Vienna. This is betrayed in the extraordinarily moving and expressively melancholy portraits of his first sick, then dying, and finally dead girlfriend Valentine Godé-Darel – among them his only free-standing sculpture, a portrait bust of his lover, dating from 1915.

Truth II (Die Wahrheit II) still dates from the first phase. In it, all is gesture, reference, appeal, stature, expression. As in an anthroposophical eurythmic dance, six enraptured male figures, scantily covered with curiously draped veils, are moving around a statuesque, sovereign-looking female figure – a symbol of incorruptible truth, standing above all else. The ground is a stylised meadow, into which delicate flowers are woven, as if into a counterpane or carpet. The background is brightly illuminated.

The dancers have their backs turned to the beholder: we can tell that they are men only by their muscular arms and legs. They are naked, their dark flowing veils doing little to cover their nakedness. Their arms are raised over their heads, their legs frozen out of the delayed movement into dramatically stable columns. On the one hand it seems as though the dancing men in this circle are seeking to pro-tect truth in the guise of the woman, while on the other, the men seem to be covering their heads when confronted by the sight of the naked truth, and, dazzled, are trying to take flight. The woman herself is not frightened; unabashed, she is giving the beholder a full-frontal eyeful. Her dark hair is gathered in long strands which surround her head like a halo, like the wigs worn by British judges, or like the well-arranged snakes of the Medusa.

The picture is reminiscent of Art Nouveau and Symbolist tableaux, revealing the artist's accommodation of the fashionable endeavours of the time. However the exaggeration, and the way he turns to the fantastical, give the painting a palpable internal dynamic, which can be felt arising between the undemanding and relatively conventionally depicted figures. It exaggerates the usual arrangement of beautiful bodies, which, detached from the real person, are pre-sented to the beholder as if on a confined theatrical stage.

It is only at first sight that Hodler's art is symbolist: superficial, arranged emotionally by form and colour, and largely devoid of con-tent. On closer inspection, however, the rational and intellectual (and intellectually demanding) elements and aims of his painting are revealed as an intention to educate. The picture is intended to make clear that the truth – in philosophy, in everyday life or in a court of law – always has to be more than a mere idealistic embodiment of an aes-thetically stylised gesture such as that associated with the mythologi-cal figure of Justice portrayed – as so often on European and Ameri-can court buildings – with her eyes blindfolded.

Hodler wishes to say that truth is, rather, a direct feature of human action and behaviour, an integral part of our lives. It should be as irrefutable and impartial as the beauty of the female body – based in itself and radiant of itself. With this austere certainty, Hodler's naked figure can, alone amongst the whole group, encounter the beholder face to face, self-assured and with open eyes. It is in this subliminal and subtle communication that the fantastical charm of this imposing picture resides.

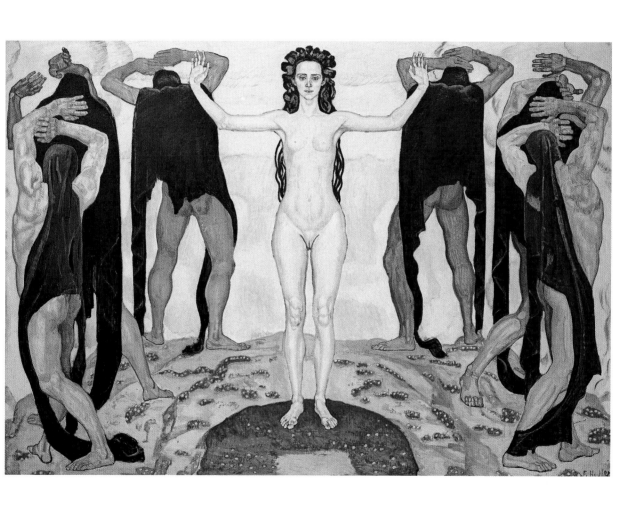

тhe Deserted city

Pastel and pencil on paper, mounted on canvas, 76 x 69 cm
Brussels, Musées royaux des Beaux-Arts de Belgique

b. 1858 in Grembergen-lez-
Termonde (Belgium),
d. 1921 in Brussels

In the person of Fernand Khnopff, an unfamiliar type of fantasist appeared on the artistic scene. He personified the sensitive, highly-strung, neurasthenic, one might almost say neurotic artist, as described by the young science of psychology at the start of the 20th century. Confrontation with one's own personality unconsciously formed one of the foundations of the artistic drive, the inner impulse. In this view, art represents the sublimation, the refinement of the artist's emotional chaos. Khnopff's pictures cast an illuminating − albeit cryptically aestheticized − light on their creator's state of mind.

The Deserted City (Une ville abandonnée) is one of the most fascinating fantastical drawings by any artist: multiply ambiguous, at the same time beautiful and threatening, eerie, devoid of people. In a realistically figurative manner, Khnopff depicts a corner of Memling Square in the Belgian city of Bruges. The windows and doors of the depicted building are closed, in some cases even walled up. Of the monument to the Netherlandish master of the 15th century, with whom Khnopff was often compared, there remains nothing but an empty plinth. The artist has disappeared. The sea has advanced dangerously near to the square. An overcast sky covers part of the city, and any demarcation between it and the silent surface of the lurking sea seems to be lost.

Khnopff, who had studied in Paris under the Symbolist Gustave Moreau, had as his source for this painting a prime example of Symbolist narrative, the novel *Bruges-la-Morte* by Georges Rodenbach, published in 1892, which also inspired Erich Korngold's opera *Die Tote Stadt (The Dead City)*. Because the sea had retreated from Bruges in the Middle Ages, and thus brought about the economic decline of the prosperous commercial city, the protagonist of the novel regards the city as having died.

In the drawing, the ambivalence, the latent tension between a number of possibilities and circumstances can be felt directly. At first sight, everything looks peaceful, tranquil, like some picture-postcard motif, with nothing in particular going on. But the longer the beholder gazes at the scene, the more strongly he or she is drawn into the silent vortex, as the eerie, uncanny aspect of this empty cityscape takes hold. Why are there no people to be seen? Where are the inhabitants? Were they forced to flee, have they been killed? If so, how? There is no sign of a disaster at first sight, yet this only makes the presence of disaster all the more palpable. In proportion to the absence of reliable clues, the fantastical element in the picture grows in significance and with it, the sensation of uncertainty, of impending threat.

In Khnopff's oeuvre, the fantastical comes through in particular in the mood of intermediacy, in the vagueness of the depiction. On the one hand, the scene is depicted realistically, while on the other everything trembles in expectation of the impending events whose outcome is uncertain. As with other artists of the fantastic, the terrifying − which, as is well known, is immanent in all beauty, from where it seems to take its inimitable course − is not artistically terrifying, but quite the opposite, namely depicted in idyllic, undemanding terms. The beauty of this picture rests on just this tension between multiple ambivalences. The secret however is not revealed; the mystery can continue in the mind of the beholder. The riddles Khnopff poses are not always solvable.

"тhe water of the old canals is weak and spiritual / full of grief in the middle of the old towns … / the water laments so much that it seems even to be mortal. / why so naked and already so devoid of existence? And does it do, / in all its sleepiness, its murky dreams, / to be not just a treacherous mirror of the hoar-frost, / where even the moon has difficulty surviving?"

Georges Rodenbach

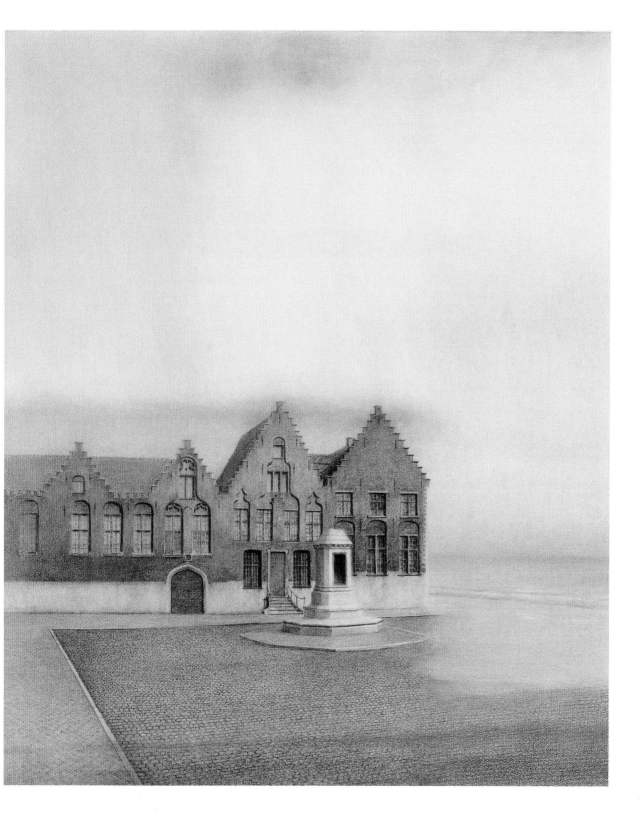

Portrait of Fritza Riedler

Oil on canvas, 152 x 133 cm
Vienna, Österreichische Galerie Belvedere

b. 1862 in Baumgarten near Vienna (Austria), d. 1918 in Vienna

Gustav Klimt is regarded today as the undisputed master of Viennese Art Nouveau. As a central figure in Viennese artistic and social life, he was the recipient of numerous honours during his lifetime, but he was also vehemently rejected by many, on account of the fact that he delt with taboo subjects linked to sexuality and death. The major portrait commissions occupy a special position within his oeuvre: not only the portrait of Fritza Riedler, but others as well, such as those of Adele Bloch-Bauer and Margaret Stonborough-Wittgenstein.

The *Portrait of Fritza Riedler (Bildnis Fritza Riedler)* is the first portrait of the "golden period", which culminated in *The Kiss*. The style is reminiscent on the one hand of the early Christian mosaics and icons which Klimt had seen in Italy in 1903. He reduces the body to the level of decoration, pure surface, albeit beautifully arranged. This particular treatment of the surface in turn places Klimt in the tradition of East Asian art, which was very much alive in the Europe of his day. Above all the elaborately produced room-screens by the 17th-century Japanese maker Ogata Korin show motifs such as wave movements that Klimt adopted directly in order to hint, for example, at the woman's throne-like chair. The sitter is placed in front of a large reddish wall, which is broken by two semicircular openings. One of these could at the same time be a Far Eastern headdress, but maybe also an echo of the hairstyle of the *Infanta Maria Teresa*, as depicted by Velázquez in 1652, a portrait which Klimt had seen in Vienna.

The ambivalence of this fantastical arrangement rests on its pure two-dimensionality, the clearly structured surface which at first sight appears to harbour no secrets. It is only the apposition of the several levels that comprise the room in which the lady is sitting, and diffusely reflect her figure, and that culminates in a condensed juxtaposition of incompatibles. The longer the beholder tries rationally to discern the various parameters of the suspected space in this picture, the less the enterprise will meet with any success: the space somehow spreads out into a two-dimensional surface once more. It is a space with no beginning or end, no entrance and no exit, a place – nowhere.

The charisma of the sitter is untouched by all this. On the contrary: it is precisely the ornamental and decorative statuesque quality of the depiction which lends her such grace. For the beholder, the result is an ideal projection screen. There are no narrow limits set to the imagination: rather, they are so broad that unimagined perspectives open up – even in more than three dimensions.

At the same time, the real sitter is enveloped in a fog of recognition. After all, Vienna, the city in which the picture was painted, was also the city in which the secret emotional sufferings of – precisely – women were at the same time being discovered and revealed to the world by Sigmund Freud. In any case, it was not done for a woman of the better sort to show her true face or her real feelings. This restriction did not however deprive her of any of her personality, but rather caused its transfiguration, at least in the visual arts.

In 1886, twenty years before Klimt painted this portrait, Ernst Mach wrote his famous "Contributions to the Analysis of the Sensations", a psychological textbook on the subjectivity of the perception of the real. Klimt made this philosophical dilemma visible: his *Portrait of Fritza Riedler* is an example, should any be needed.

"There is no self-portrait by me. I am not interested in my own person as the subject of the picture, but rather in other people, above all females, but even more in other phenomena. ... Anyone who wants to know anything about me – as an artist, the only noteworthy aspect – should look at my pictures carefully and seek to use them to understand what I am and what I want."

Gustav Klimt

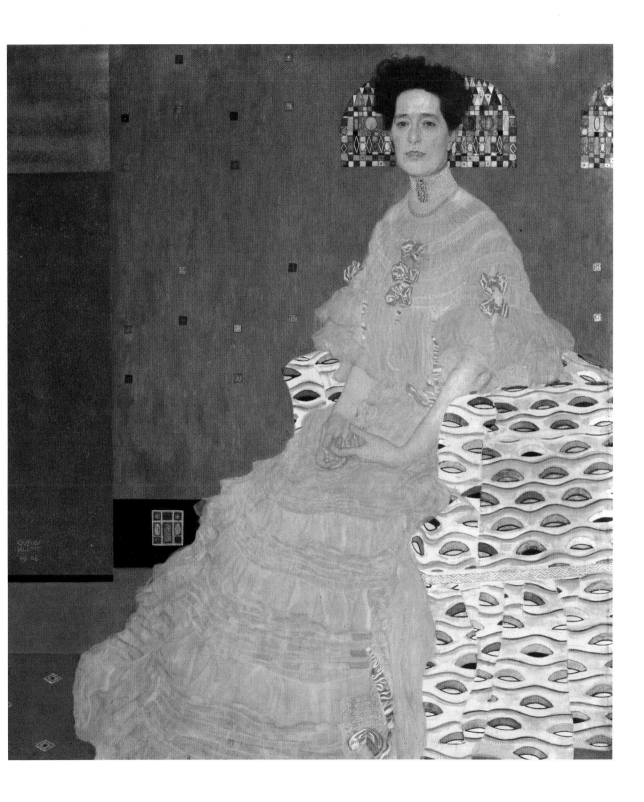

Roger and Angelica

Pastel on paper, 92.7 x 73 cm
New York, The Museum of Modern Art, Lillie P. Bliss Collection

**b. 1840 in Bordeaux (France),
d. 1916 in Paris**

Odilon Redon embodies the archetype of the fantastical artist towards the end of the 19th century. His art, under the strong painterly influence of the Symbolist Gustave Moreau and given literary shape by writers such as Edgar Allan Poe, Joris-Karl Huysmans, Charles Baude-laire and in particular Stéphane Mallarmé, can be divided into two phases. The first, unambiguously mysterious, consists primarily of gripping graphic works in black-and-white, using the two-dimensional techniques of etching or lithography: symbolistically creepy romantic shapes are linked with favourite fantastical themes such as dreams, night or sea-monsters. The second period consists of radiantly colourful pastel drawings of mythological and historical figures. In the process, Redon also succeeded in creating astonishingly abstract and, as we might say today, "informal" pictures. The combination of dreams and reality also seems to anticipate Surrealism. In addition, Redon adopted some of the stylistic elements of decorative art and in this sense is an immediate precursor of Art Nouveau.

It was said of the young Redon that he had observed the clouds chasing across the sky over the flat landscape of Bordeaux, where he grew up. Their shapes, it was said, had inspired the fantastical formations which he invoked in his paintings, drawings, lithographs and pastels.

In his pastel *Roger and Angelica (Roger et Angélique)*, too, we see reflected his perfect ability to express his rich imagination through colour, light and shade. The picture dates from the final period of his creative life, when colour enchanted him. Even though this work was created in the 20th century, it breathes the spirit of 19th-century Romanticism, when feeling triumphed over form, and colour was its expressive medium.

Redon conjures up a scene from a 16th-century novel, *Orlando Furioso* by Ludovico Ariosto. The knight Sir Roger chases past on a fiery black horse in order to save the king of China's daughter from a dreadful fate: a dragon can be discerned on the left, its baleful inner glow heralding no good intent. Those who know the story will also know that it is Orca, who devours virgins. Swirls of threatening fog rise up around the princess, while above her, dark clouds lower. The human beings themselves are small, and drawn with rapid strokes on the paper; it is the atmospheric effects, generated by chiaroscuro contrasts and the amazing use of colour – also true of the imposing rocks to which Angelica is tied – which create the first-class drama of this tension-laden scene.

But it is narrative gone over the top, as Redon himself admits: "The designation of my works on paper by a title is perhaps overdone. The title is only justified to the extent that it is vague, indecisive, and even seeks to be obscure and ambiguous. My drawings are suggestive, they cannot be defined. They define nothing. They take us, like music, into the ambivalent world of the undefined …"

Redon's fantasy is based, from the point of view of content, on historical motifs, such as we also find with other fantasists and Symbolists like Edward Burne-Jones or Fernand Khnopff. However, its sophisticated composition saves it from getting stuck in the rut of timeless tradition.

> "Nature also requires us to pursue the gifts she has bestowed on us. Mine have led me into the world of dreams; I have allowed the torments of the imagination and the surprises that it came up with beneath my pen to flow over me; but I have led and guided them, these surprises, according to artistic laws, for the sole purpose of using a spontaneous stimulus to summon up in the beholder – to its whole extent and in all its attractive power – the uncertainty that lies at the extreme ends of thought."
>
> **Odilon Redon**

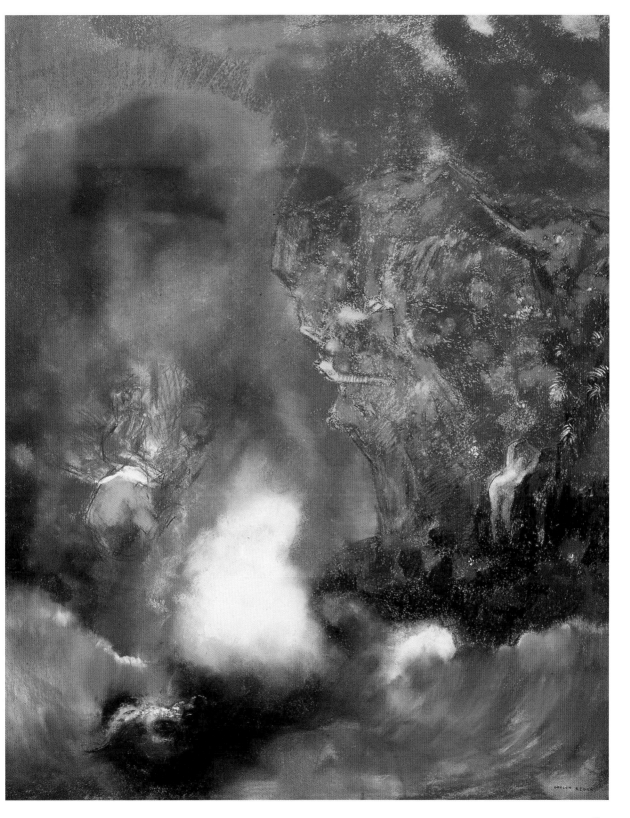

тhe Dream

Oil on canvas, 204.5 x 298.5 cm
New York, The Museum of Modern Art

**b. 1844 in Laval (France),
d. 1910 in Paris**

Henri Rousseau's pictures refute the notion that the fantastical was above all a product of an overbred and overheated civilization. In his case, it was, rather, a result of individual and exotic reveries and strange extravagances. This "douanier" (customs officer), as he was referred to by his academic fellow-artists after taking up this day-job in 1869, at first deprecatingly but later with great respect, displays the astonishing phenomenon that art and the imagination that goes with it are not primarily a matter for an academy, but, rather, basically one for the human spirit and human sensibility.

In order to avoid a scandal relating to a petty theft, Rousseau, a law clerk, joined the army in 1863, but never saw any far-off action himself. Perhaps he was stimulated by the tales of his comrades to invent his own journeys. This painter at any rate did not have to travel great distances in order to experience the alien and the exotic; visits to the Paris zoo and botanical gardens provided inspiration enough. From 1884 he additionally had a permit to draw in the national museums, and from 1886 he took part in the annual Salon des Indépendants.

In Rousseau's *The Dream (Le rêve)*, the last of his great jungle pictures, we set eyes on a longing for unspoilt nature. Just as Freud interprets our dreams scientifically, Rousseau interprets them artistically and ingeniously in primary colours and forms. The picture comes across as simple and insightful yet complex and mysterious: uninterpretable. A young woman is resting on a chaise-longue in the middle of a dense forest of leaves, flowers and tendrils. A drawing-room seating arrangement in the jungle: as we know, anything is possible in dreams, and at the same time, everything is impossible. In the background, a figure who is almost melting into the jungle is playing a flute. From the thicket, a lion is staring directly at the beholder, while the lioness at his side is gazing, if anything dreamily, at the naked recumbent figure. The trees are populated by all kinds of exotic creatures and between the foliage at the right-hand edge of the picture can be seen the disc of the full moon.

This picture captivates us through its harmony: the harmony of the detailed arrangement of the forms and the harmony of the confrontation. These are the sole sources of the unique effect of the logically impossible. None of the individual items fit together, and yet the whole radiates an inimitable magic; the logic of the dream simply obeys different laws.

At the dawn of the 20th century, it was fashionable to discover the distant, the exotic and the archaic, and many artists waxed enthusiastic about so-called primitive art. The young Pablo Picasso – who in 1908, half in jest, half serious, arranged a banquet in honour of the "douanier" – collected African sculptures, the painter Paul Gauguin went to Tahiti, the poet Arthur Rimbaud to Africa: But a petty official in Paris?

Like other "eccentrics" – for example Simon Rodia in Los Angeles and Fernand Cheval in France – he was content to take his own sensations, including his dreams, desires and yearnings, so seriously that in the end he could regard them as real. From this self-created truth, there grew a whole cosmos of alien pictures.

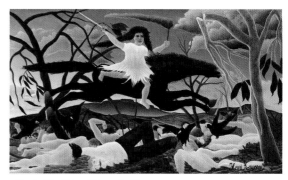

War (or The Ride of Discord), 1894

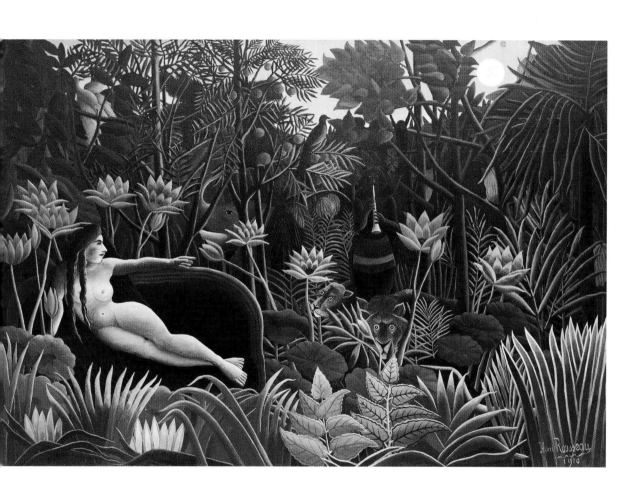

The Poet's Pleasures

Oil on canvas, 69.5 x 86.4 cm
New York, The Museum of Modern Art

**b. 1888 in Volos (Greece),
d. 1978 in Rome (Italy)**

Giorgio de Chirico's deserted Italian piazzas (*Piazze d'Italia*) have been unique phenomena in painting since the early 20th century. Having appeared as if from nothing, without precursors, they assert their position amidst the turbulent artistic currents of the time. De Chirico, a Greek-born Italian, who studied at the Academy in Munich where he was influenced artistically by Max Klinger and Arnold Böcklin, and philosophically by Friedrich Nietzsche, opened up with his fantastical townscapes hitherto unseen perspectives, putting a psychologically spatial stamp on our perception. Human dreams, yearning and unquenchable desire found their home in de Chirico's imaginary scenes.

Like colourfully painted theatrical backdrops, de Chirico's lifeless buildings and faded façades artificially surround the empty space of an alien circumstance into which the beholder can project his or her own ideas. The empty piazzas are, after all, the artistic settings for psychological imaginings, not geographical reality.

De Chirico painted his *The Poet's Pleasures (I piaceri del poeta)*, a key work in his important series *Piazze d'Italia*, in 1913. It evokes not events that can be named or shown, but, rather, psychological states such as fear, melancholy, depression, loneliness, eeriness, mysteriousness and leave-taking. At the same time, no dark places are revealed at first sight; on the contrary, everything shines out in clear colours, everything is simply and harmoniously composed from just a few architectural set-pieces, a few technological achievements, and a blue sky. But the way in which this becomes the stage on which a dream is played out is both inimitable and infectious. What we first notice is the light, which, continually changing and never unambivalent, conjures up a mood as of early morning or evening twilight. The shadows, placed in the centre of the picture where they cannot be overlooked, are the gripping signs of a barely perceptible, but effective change, a turning point. The emptiness is additionally underlined by the almost total absence of people, other living organisms or everyday objects. Only an unrealistically small figure – the lonely poet? – is disappearing, detached and turned away from us, into the distance. There is only the whitish-grey cloud of steam from the chimney of a hinted-at railway locomotive behind a stone wall to bear witness to life and movement.

Otherwise, time seems to have become frozen. Tough as mildew, it spreads across the spatial dimensions and covers them with a thick veil of multiple ambiguity. Everything is as it is – and at the same time different. The walls of the houses and other buildings are clearly structured, everything is in its place and yet everything is slightly out of kilter, as signalled by the barely perceptible shifts of perspective. In the wall of the house on the left, the first cracks can be seen.

The term "metaphysics" – de Chirico's painting style is known as "Pittura metafisica" – is to be understood literally: only beyond known and interpreted reality does the more essential and further-reaching realm of the soul begin, the site of the unconscious. De Chirico was well versed in philosophy, though his attitude towards it was reserved, because he wanted to demonstrate something new through painting; and he is one of the most important artists of the 20th century, since he created facts which no one can deny. His enchanted spaces represent the imaginative surroundings of transformation and illusion. Thus they vouchsafe an insight into the psychological plane of the fantastic, and give beholders the opportunity to come closer to themselves.

"… the work of art must have neither reason nor logic. In this way it approaches the dream and the mind of the child."

Giorgio de Chirico

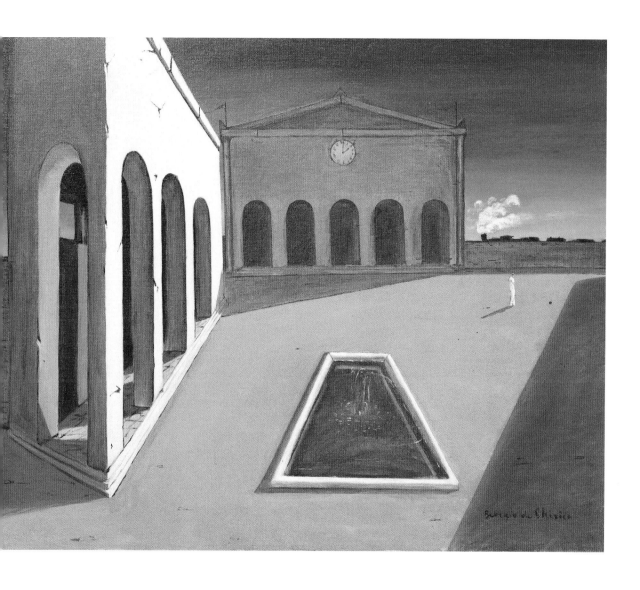

тhe metric system

Oil on canvas, 146.4 x 99.1 cm
Philadelphia, Philadelphia Museum of Art, The Louise and Walter Arensberg Collection, 1950

**b. 1880 in Nantes (France),
d. 1950 in Milan (Italy)**

The French painter Pierre Roy is one of that not rare breed of "unknown geniuses", the description sometimes applied rather extravagantly to those artists who achieve something unique, but yet remain broadly unrecognized. And yet his pictures are true gems of aesthetic surprise, painterly sophistication and incomparably overflowing imagination. For all this, Roy raises everyday things and views almost imperceptibly into the events of a poetically painterly enchantment.

Roy, who was related to Jules Verne (1828–1905), the author of science-fiction adventure and exploration novels such as "Journey to the Centre of the Earth", at first trained in an architects' office, before studying at the École des Arts Décoratifs in Paris and finally working at the Académie Julian. As early as 1925 he was exhibiting together with the Surrealists in one of their first shows.

Roy is the alchemist of fantastic art. He transforms the unassuming into the magical, the everyday into the unique, and the ordinary into the special. When for example he lines up the objects in his painting *The Metric System (Le système métrique)*, it is at first little more than a tableau filled with various appliances developed by mankind in the course of history in order to be able to carry out measurements of all kinds, and in order to arrange his world in a more orderly fashion. But in this picture, the beholder looks beyond all this into a laboratory of the artificial, and into a veritable chamber of measuring curiosities.

To the left and right, on high walls distempered by light green, we see long measuring-rods, and narrow shelves with other aids to measuring a whole variety of quantities and qualities. On the light-coloured floorboards are containers, dishes, and beakers of various sizes, while on a wooden table to the left in the midst of further measuring objects stands a pair of scales, and on a little table to the right a theodolite, an instrument for measuring horizontal and vertical angles.

The back wall has a narrow opening into the open air. Above it hang portraits of scholars from the field of physics and mathematics. A metal pendulum hangs down from the ceiling. Through the exit, we can see into a tidy landscape of green fields and well-trimmed hedges, between which a small figure is sitting on the ground, who also seems to be concerned with measurements. In the distance on the horizon a cloud of smoke rises from a fire into a sky which is an even blue all over. Roy expresses a certain melancholy about the fact that the spirit of the Romantic Age has not survived into the present, in which the metric system with its consequences and the smoking chimneys of the factories are the dominant features.

The magic of the picture arises not from the individual, exactly reproduced objects and the interlocking spaces, but only from the whole. The psychological law of vision, according to which the whole is more than, and different from, the sum of its parts, is here, fantastically and directly, made the centre of interest. When beholders can be enthused by precisely these instruments of science, then this pictorial composition will make all the stronger an impression upon them, awakening their will to go on observing and go on discovering, in order finally, via their own imagination, to enter into a different world of the real and the unreal, the possible and the impossible. Using the stipulations laid down by the artist, it is possible to measure out the ego. In masterly fashion Roy has painted out for us the relationship between fantasy and experience of the world.

> **"As a painter, I have no philosophy whatever. when I paint anything at all, I do it out of the sheer pleasure of painting. I have no symbolic intention whatever. But very often, sometimes long after the completion of a picture, I become aware of what inspired me and of what my canvas signifies."**
>
> **Pierre Roy**

expectation

Oil on canvas, 81.6 x 100.6 cm
New York, The Museum of Modern Art

**b. 1900 in Magdeburg (Germany),
d. 1980 in Posteholz**

Richard Oelze's painting *Expectation (Erwartung)* has a fantasy which is all its own. On the one hand it is one of the most mysterious and uninterpretable works of all, while on the other it has become an icon of the European art of the 1930s, because, like no other picture, it strikes a certain chord which is in harmony with the imagination of the age. In addition it can also be seen as a kind of mirror image of the artist, whose personality remains somewhat of a puzzle to this day. Oelze was a recluse; even when he was living in Paris, from 1933 to 1935, he maintained only very loose contact with the Surrealists, to whom he had actually felt quite close ever since seeing his first Surrealist pictures in 1929. He painted his own visions, independently of all external influences, whether it be his training (at the Bauhaus), his places of residence (he lived in Worpswede for 16 years), or his fellow-artists with a similar cast of mind. He destroyed a large proportion of his oeuvre, painting it over in black, tearing it up, or burning it.

The atmosphere of *Expectation*, which was painted in Paris, is veiled and overcast; just a few browns and greys are hesitantly bathed in a wan yellow. The focus of the action, such as it is – a mysterious and opaque process – is played out in the broad expanse of the sky. It becomes visible in a dark mixture of streaks and clouds which are depicted gathering wildly and full of movement into something full of tension: distant summer lightning. Sparingly placed shrubs, reminiscent of one of Oelze's early fernlike forest scenes, characterize an expansive landscape, which slopes gently downwards towards dead ground in the centre of the picture. This plain looks like a long-drawn-out area of colour in which nothing happens and nothing is to be seen: a truly blind spot, which the beholder could easily overlook, as it is the source of no stimuli, but which, the longer one looks at it, becomes the second venue for a dramatic event.

For outside of this plain, in the foreground at the bottom edge of the picture, there stands a group of people in city hats and coats, all apparently on the lookout for something. They have their backs turned to the beholder, so that we are looking over their shoulders, so to speak. Only one man and one woman are not looking in the same general direction. The tension in these figures, infectious and almost palpable, constitutes the nucleus of this fantastically charged scene. It seems to be in the nature of impending catastrophes that their early-warning signals are not, or are only vaguely, recognized. Every great disaster starts with small signs which are hardly perceptible. In this sense, the picture may suggest that in 1935 a small group of people were already trying to make out the signs of the general conflagration which not long afterwards was indeed to consume the world. The fantastical aspect of this picture is thus to be sought in this latency and ambiguity, which stylise a contemporary document into a prophetic vision.

Even if it should turn out that Oelze was not painting an artistic premonition of Germany's fate in that period, from the purely aesthetic point of view he has created an incredible picture, from which can be extracted a great deal that was perhaps put into it unconsciously. But the tense waiting alone creates a force field of intensity that, beyond the confines of the frame, captures any beholder. Without any obvious drama in the picture, without any imposed colour games, without unambiguous events, and absolutely without any overt didactic gesture, the painter has evoked a tragedy which is without parallel.

> **"I would never have had to see a landscape in order to paint one."**
>
> **Richard Oelze**

blind power

Oil on canvas, 179 x 100 cm
Berlin, Berlinische Galerie, Landesmuseum für Moderne Kunst, Photographie und Architektur

b. 1890 in Calw (Germany),
d. 1955 in Munich

Rudolf Schlichter is remembered first and foremost as a virtuoso portraitist of the 1920s – one only has to think of his pictures of the literary figures Bertolt Brecht and Egon Erwin Kisch – and then of course for the erotic paintings and drawings which reflect his obsession with submissiveness to high-booted dominatrices. But at least one painting, *Blind Power (Blinde Macht)*, which he painted during the heyday of National Socialism in Germany, distinguishes him as a notable fantastic artist. It is a one-off not only in Schlichter's oeuvre but also in the body of German painting at the time.

The picture is associated intellectually with a story by the writer Ernst Jünger, with whom the painter was befriended until his death. Jünger's "Auf den Marmorklippen" (1939; English translation "On the Marble Cliffs", 1947) is often seen as containing cryptic allusions and a prophetic premonition of the subsequent horrors of the Third Reich. In Schlichter's case too, a link and a pictorial reference to the political and social conditions in Germany and the military events of the period can only be guessed at rather than overtly recognized.

The "blind power" is an allegory of destruction. Military conflict is personified by Mars, the god of war, who, in spite of his mighty stature appears helpless as a result of his closed visor, in other words "blind". His field of vision is restricted, he is literally blinkered against distractions from the side and thus against superfluous thoughts and considerations: he can fulfil his destructive mission without scruple.

On the canvas, this giant is striding machine-like across the deserted plain, which shows no traces of life except possibly from the fires still burning in the background. With taut muscles, his right hand is gripping a huge hammer, while around his muscular lower arm are two wooden triangular set-squares as used for geometrical drawing; the left hand is firmly holding a short iron sword. The left calf is pro-

tected by a metal leg-guard with warlike symbols – the knee-joint is in the form of the head of a ram, the symbol of Mars. The god of war, to whose innards a homunculus and all kinds of repulsive parasites have attached themselves, is taking long strides towards the edge of a cliff, which falls away precipitously into an abyss.

The fantastical aspect lies in the paradox of the shiny insignia of the warrior, which seem not to be in accord with the martial gestures of the whole: the drawing implements point to a scientist or artist rather than to a destroyer, and the artistic decorations of the short tunic and helmet would be more appropriate to an athlete. But it is precisely behind the subtly attached insignia that the actual danger posed by a quite new sort of war actually lurks. Killing is becoming more and more a scientific affair, the remote control of machines. Schlichter, who avoided action in the First World War by going on hunger strike, predicted this accurately, and depicted it through fantastical exaggeration even while phrases like "peace in our time" were still being bandied about. The Nazis were well aware of the dangerous potential of the fantastical vision: Schlichter received a caution in respect of this picture in 1937, and 17 of his paintings were confiscated the same year, some being shown in the "Degenerate Art" exhibition.

> **"so we stagger along, between apocalypse and lost paradise, very close to the former and very far from the latter; torn between yearning and self-hate, lost in dreams and escaped from dreams. And that is what I seek to express in my pictures."**
>
> **Rudolf Schlichter**

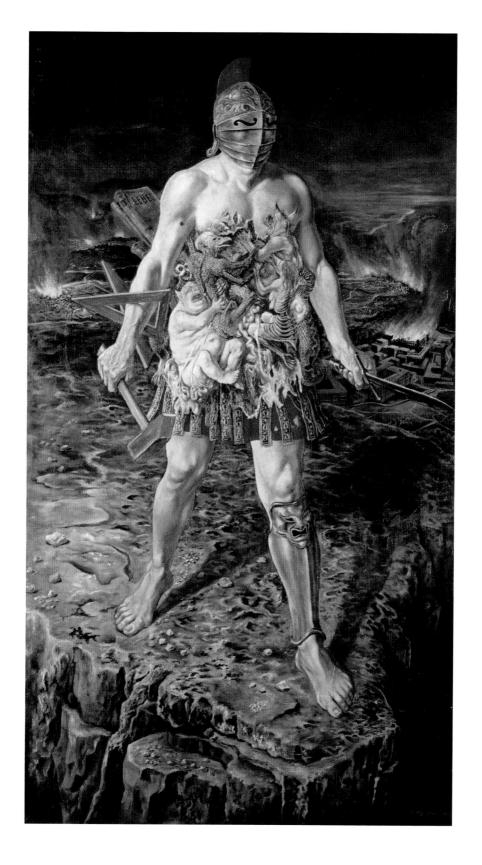

ınterval of the ʌpotheosis

Oil on canvas, 64 x 45 cm
Private collection

b. 1908 in Buenos Aires (Argentina), d. 1996 in Paris (France)

Leonor Fini's pictures are views of twilight. Not particularly original in their content, they are yet captivatingly original in their composition. Simply the way the artist plunges the figures into the labyrinthine corridors of her imagination is unique and convincing. Born in Buenos Aires, Fini grew up in Trieste and spent most of her life in Paris, where she absorbed her most important inspirations from the Surrealists, with whom she also held joint exhibitions. In the pulsating French capital and in Europe generally between the wars, this self-taught painter represented a magnificent catalyst among the titans of art during this period.

What we see in her pictures are not insights but sights. Thus the artist makes free use of the repertoire of fantastic art of the past two centuries. Her pictorial space is populated not by human beings, but by supernatural figures such as virgins, youths, hermaphrodites, narcissi, witches, furies, sea serpents, and other characters from the property-box of myth and fairy-tale. In the interplay of these creatures, Fini evinces an amazingly sure sense of style. At the same time she has taken to heart one of the basic principles of Gestalt psychology, according to which the whole must form a so-called figure. The groupings, the combinations of the individual figures, which individually sometimes come across as wooden, results in a genuinely novel tableau full of surprising sights. The mysterious quality of her pictures is based ultimately on the vague, diffuse light, in which everything seems to be plunged. Intermediate worlds open up, inviting beholders to an adventurous viewing session.

The *Interval of the Apotheosis (L'entracte de l'apothéose)* can be seen as an exemplary case study. The heroine, a tall androgynous being – as in many of her paintings, not dissimilar to the artist – occupies centre-stage. Already as good as stripped, she is now in the process of divesting herself of her red stockings and one of several

splendid headdresses. Devoid of emotion, she stares at the beholder, who can feast his or her eyes in fascination on her excessively long sylphlike figure. The voyeuristic dialogue is however disturbed by the presence of the old hags lurking behind this perfect figure and contorting themselves in lascivious gestures. These three wicked witches are dancing around the virgin, clumsily and with their arms held in the air. They are tearing at the long hair or pulling self-destructively at their own faces until the skin could come away like a mask. Their ungainly misshapen bodies are dressed in grey tattered rags. On the ground lie two more piles of black hair and a few remains of stone columns. Otherwise the ochre earth is barren and empty, and merges into a blurred nocturnal sky.

A night picture of the history of fantasy: after all, apotheosis – ascent into heaven – represents the raising of the individual to the status of a god, a cult which Alexander the Great made into a state religion and which played an important role in the Roman Empire. During the Baroque, the Assumption of the Virgin was a favourite subject. In Fini's case, however, the well-known religious context is extended to include a pagan component. As at the start of Wagner's "Götterdämmerung" or in the beholder's dreams, the evil ones, the Norns, are unwinding their baleful pronouncements, while centre stage, unmoved by all this, the beautiful one – or the dreamer him or herself – can take pleasure in her own existence. Fini re-creates the manifold fantastical voices and phenomena of the in-between places in such a way that the attentive beholder can see hitherto undreamt-of aspects of his or her own personality.

Composition with Figures on a Terrace, 1939

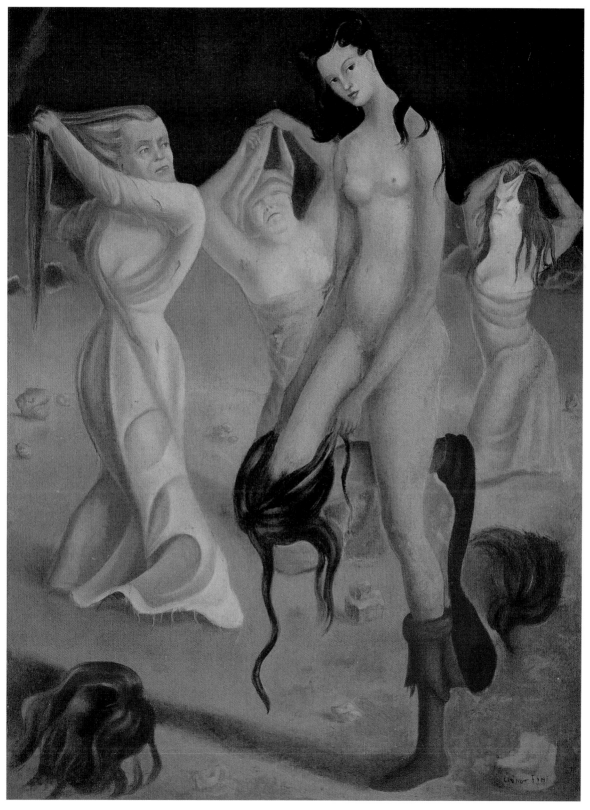

birthday

Oil on canvas, 102 x 64.8 cm
Philadelphia, Philadelphia Museum of Art

b. 1910 in Galesburg (USA)

This is the most famous picture by the American artist Dorothea Tanning, and it remained in her possession until 1999: *Birthday* was painted in 1942, the painter having recently met the Surrealist Max Ernst, whom she was to marry the following year, and with whom she was to stay together until he died in 1976. It was he who suggested the title of this picture.

At the age of 20, Tanning enrolled at the Chicago Academy, where she held out for just two weeks before making a living of sorts as a photographic and artists' model, and working as a freelance illustrator for department stores. A decisive moment in her artistic career was the great "Fantastic Art – Dada – Surrealism" exhibition at the Museum of Modern Art in 1936.

A strangely disturbing scene opens up to the beholder of *Birthday*: a suite of rooms stretching far into the distance, with the perspective vanishing point at the top right. Other rooms lead off the first room, which open a view through opened doors with conspicuous round knobs into yet more rooms. Dark, diagonal boards form the floor of the whole apartment, in which as far as can be seen there are no articles of furniture, no other objects and no people either. The emptiness grows into an unspeakable uncertainty. The impression of a déjà-vu experience is hard to avoid. Have we perhaps seen similar scenes in a film, maybe at the start of a Hitchcock thriller, in which the aim is to create an unbearable tension – where we know nothing, yet have a strong sense of foreboding?

Coming from the left, still holding her hand on the doorknob, a young blonde woman – with the features of the artist – with bare breasts and narrow bare feet, has just entered the room in the foreground. Her total appearance, with hair let down, her mauve blouse torn open, and her shimmering mulberry skirt, from the waistband of which a tangle of prickly roots or bundles of seaweed is hanging,

gives her an ambivalent charisma: is she a ghost, a witch or simply a beautiful woman? The incomprehensible nature of this person is made worse by the presence of an unpleasant creature, part eagle, part bat, part cat with a long tail, which, like a mythical griffin, is squatting on the floor and giving the beholder a malign stare through devilish eyes glowing yellow and red. Maybe it is an ally of the protagonist in the adventures which are still awaiting her in this hallucinatory space.

To judge by the title, *Birthday*, all we have is a somewhat eccentric depiction of the painter. But it is clear that the unusual design of the rooms allows for other interpretations too. In a country in which social status plays an important role, the empty, deserted labyrinth of rooms, which lead to an uncertain destination, or straight into nothing at all, cannot but give rise to confusion. To be a social creature – to be known, to be liked – is the ideal; to be asocial – marginalized, unpopular – or simply to want to be alone for a while, is, conversely, a defect.

In Tanning's pictures, by contrast, it means normality and freedom, that a person can also live and feel comfortable without a family or friends. This is one of the sublime provocations of this picture, and a reason why it engraves itself so intensely on our memory. In addition, it depicts a woman acting freely, assuming her role in the art scene with self-confidence. This self-assured attitude is what gives her art its lasting effect.

"Dorothea Tanning paints spaces inhabited by little girls dressed in rags; the journey 'through the looking-glass' seems to have turned them into demons, and they wander along corridors with slamming doors and tear the wallpaper into shreds or find giant sunflowers on the stairs, stretched out like the suits of armour of gigantic knights."

Marcel Jean

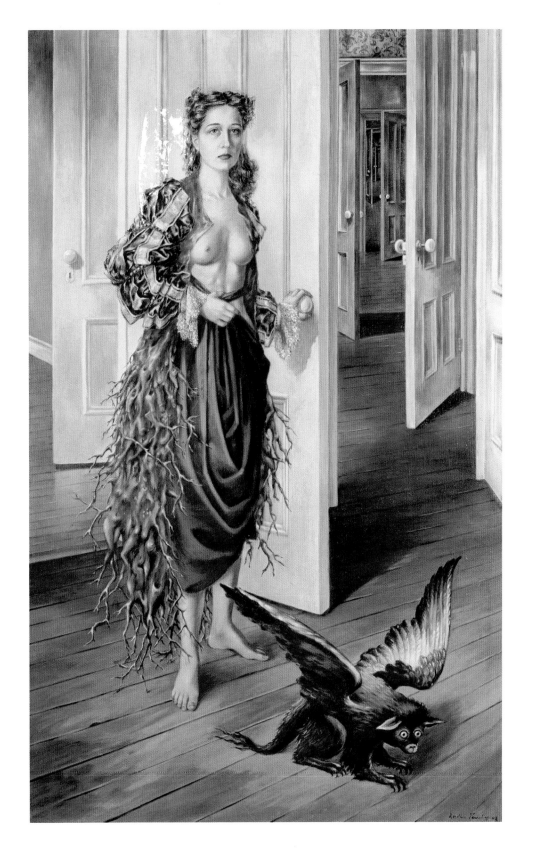

Poetry of America
– The cosmic Athletes

Oil on canvas, 116.8 x 78.7 cm
Figueras, Fundació Gala-Salvador Dalí

**b. 1904 in Figueras (Spain),
d. 1989 in Figueras**

Salvador Dalí is probably the artist who most closely approaches the essence and also the cliché of the fantastic painter. His philosophies of art are simply too ingenious, his craft skills too great, his horizons too sophisticated, and his preferences too weird. This is a painter you can believe capable of anything. To do justice to such exaggerated expectations is too much for even such an amazing metamorphosis artist as Dalí. No wonder then that his art to this day is either overvalued or undervalued. But however that may be, his extensive oeuvre contains such gems such as *Poetry of America – The Cosmic Athletes (Poésie d'Amérique – Les athlètes cosmiques)*.

From the point of view of structure, the picture is a traditionally composed, meditative devotional image with two main figures, which occupy two-thirds of the foreground, and a seated naked man, in proportion to the others too small, at the left-hand edge; the remaining third of the pictorial space behind is dominated by a massive tower-like monument with a large clock, standing beneath a round arch against a night sky. The ground is a sandy brown, the variable slopes already giving it a Surrealist look. What comes across as fantastical, though, are the two "athletically" well-proportioned protagonists, one white, and clad in red and blue apparel, and a young black man, naked apart from his arms and head; a drawer is growing out of his hip, while a smaller brother has emerged from his back. His fellow-player or opponent has a pot-like dish with a burning candle in place of a head, and from his right breast is hanging a Coca-Cola bottle, from which a viscous black mass is flowing onto the ground; this figure has no lower arms or hands. A preliminary analysis could establish that the deformed, decadently recessive white race is confronted by an outrageously healthy, athletically well-formed black race.

On the distant tower there hangs a soft, matt white form in the shape of the African continent, albeit somewhat distorted. Africa as a continent loses political clarity to the extent that elsewhere its inhabitants gain in physical profile. The young man sitting naked on the ground on the left-hand side of the picture seems to be untouched by all of this; he is concentrating merely on balancing a vertical white pole. The poetry of the great American continent, which fascinated the artist both before and after the Second World War, seems not so much to derive from the confrontation of the two figures as from the co-operation of the two bodies. They are the protagonists accessible to the senses, the embodiments of two fates competing for attention and facing each other incompatibly. The curves of their joints and muscles are almost haptic, while the elegant turn of their beautiful bodies in movement is infectious. Of their souls there is nothing to be seen – but everything to be felt.

The effect of the picture derives from the combination of unassuming individual details, and the shimmering atmosphere hanging over what is actually a non-event. Dalí, who not infrequently crowded his pictures with numerous objects, this time leaves the beholder space to introduce his own ideas. Here the singular fantasy of Dalí's art can be experienced directly in the beguiling and self-assured colouration, the smooth round forms and in particular in the empty areas, which invite us to wander further, and to imagine further. Not least, Dalí has with this picture paid tribute to that America that threatened to sink into a morass of clichés and which nonetheless – and be it in the body of each individual inhabitant – continues to re-invent itself in a fantastically unique and "poetic" manner.

> **"I think I am, in what I create,
> a rather mediocre painter. what
> I regard as brilliant is my own
> vision, not what I actually create."**
>
> **Salvador Dalí**

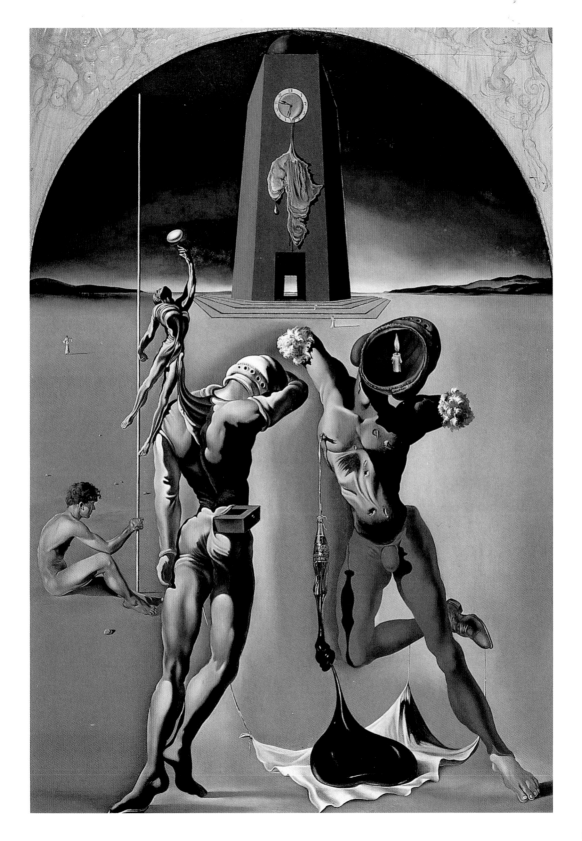

тhe вroken column

Oil on canvas, 40 x 30.7 cm
Mexico City, Museo Dolores Olmedo

**b. 1907 in Coyoacán (Mexico),
d. 1954 in Coyoacán**

Appreciation of the Mexican artist Frida Kahlo has reached unheard-of heights in recent years, whether as a result of celebrity collectors such as Madonna or of the Hollywood film of her life. Her political commitment in the Communist Party and her double marriage to the famous Mexican mural painter Diego Rivera (1886–1957) have also contributed to the creation of the Kahlo myth. Although her fascinating personality has played a larger role than her art in all this, her painting has also become a focus of interest. Occasionally the artist's tragic fate has come between her art and its interpretation. However the fact that Kahlo's work represents far more than just the subjective processing of her own experience now seems to be beyond question, and indeed is proven by the art itself.

At the age of six Kahlo fell victim to poliomyelitis, which left her with a crippled left leg. Nonetheless, she managed to recover her mobility and joie de vivre. In 1925, though, when she was an 18-year-old high-school student, she was involved in an accident which totally changed her life. In the course of a collision between a bus and a tram, she was transfixed by a metal rod on one of the vehicles – of the kind used by passengers to hold on to – and it was little short of a miracle that she survived. She suffered 17 fractures, injuries to her spine and abdomen, and a crushed foot, all of which kept her in bed for several months.

In order to distract herself from her injuries during this time, she taught herself to paint, and having done so, engaged in self-therapy by painting self-portraits, thus sublimating her physical and psychological suffering on the canvas. For this purpose she was given a special sort of easel as a present, and a mirror was specially fixed to the ceiling. Time and again she was thrown back on her own resources as a result of necessary additional operations. She suffered a number of miscarriages and finally had to undergo an amputation.

One of her most famous paintings, *The Broken Column (La columna rota)*, is both unusual and moving. At the time it was painted, her medical condition was deteriorating, and she was required to wear a variety of orthopaedic corsets. The picture depicts Kahlo with her torso opened up to reveal an Ionic column broken in many places, symbolizing her injured spine. Her upper body, naked and, like her arms and face, pierced with nails, is in a surgical corset.

The figure is set in a desert landscape scarred by deep crevices, and with no sign of life of any kind. From a face with a serious expression, the eyes, wide awake beneath strong, gently rounded eyebrows which join in the middle, look directly at the beholder. The corners of her mouth are marked by a barely perceptible touch of melancholy wakefulness.

This picture is bound to rouse memories of countless European depictions of the martyrdom of St Sebastian. But the shock of this surreally immediate and brutal perception of the opened-up body with its broken column, whose capital, directly beneath the sitter/painter's chin, thus appears to support her head, goes much deeper than this. In a surgical textbook, it may be normal enough to see physical injury depicted as directly as this, but in art, such subjects are always given an aesthetic makeover, and are presented indirectly. To depict suffering thus unveiled is new. The fantastical aspect lies in the shock felt by the beholder on looking at this picture. But it is precisely this openly displayed naturalistic objectivity which is subjectively moving, and from which ultimately no one can escape.

"Neither (André) Derain nor you nor I, none of us can paint a head as well as Frida Kahlo."

Pablo Picasso to Diego Rivera, 1939

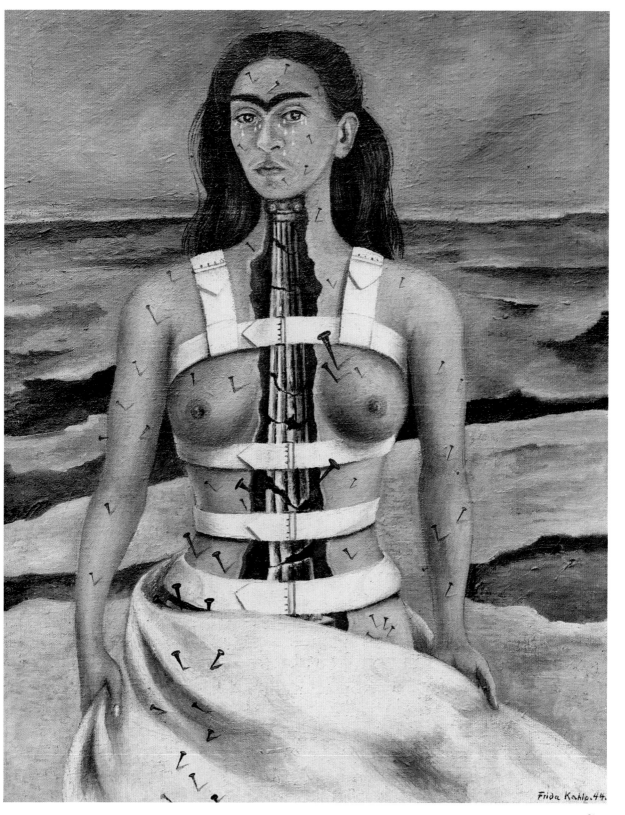

THE DOLL

Painted wood, hair, socks and shoes, 61 x 170 x 51 cm
Paris, Musée national d'art moderne, Centre Pompidou

b. 1902 in Katowice (then Germany,
now Poland), d. 1975 in Paris (France)

Hans Bellmer's *The Doll (La poupée)* represents a unique artistic object even in the broad landscape of fantastic art. From the outset, other artists, along with critics and above all an incredulous public, have rubbed their eyes in disbelief when confronted with Bellmer's doll games. Although he was befriended with the Surrealists in France, he was ultimately a loner with curious characteristics. His first doll dates from a period in which, repelled by National Socialism, he gave up his work as a graphic artist and turned his back on his German homeland. In his intensive sculptural work, he sublimated the erotic attraction he felt for his then 15-year-old cousin Ursula, and which he sought to shield himself against. After that he continued to work intensively on his idée fixe, creating further dolls from all sorts of materials, in all shapes, colours and functions, mobile and immobile; in addition, he took photographs of them, wrote strange poems about them, and finally compiled a documentation in which various interpretations were presented and interpretative models for his art were provided. The dolls have never lost their fascination and represent a form of highly original fantasy.

The complete cycle of dolls comprises three-dimensional jointed mannequins painted and dressed in various ways. Placed in a variety of contexts – for example in a park, beneath trees, on a meadow full of wild flowers, on the steps of a staircase or in a cupboard – they are intended to fulfil certain functions, play variable roles, and thus embody individual orientation points for various requirements. That these dolls do not represent mere objects for sexual fetishists is due not least to the coolness and aloofness emanating from them. Their fantastical qualities and the focal point of their aesthetic existence are to be found in their artistic embodiment.

The example in the Centre Pompidou is one of the mobile dolls, which, as Wieland Schmied put it, "are reflected around the navel as the centre of their ball-joint – a monster with two laps, two pairs of legs, two pairs of feet in small black patent-leather children's shoes, and a superfluous head, at the same time fantastical and terrifyingly real, transformable and yet always the same, innocent and unknowing, childlike and perverted, vampire and succubus, a jointed construction of enormous intensity and at the same time one of the most convincing sculptures of our age".

Psychologists see an object not just as such, but also as a substitute for a different object. In this sense, Bellmer's *Doll* is to be interpreted as an object – also a substitute object – for erotic needs. Bellmer's *Doll* is a substitute for the image of a woman as a sexual object and as the subject of countless fantasies which can be projected on to it.

As Bellmer put it: "I think that the different categories of expression – posture, movement, gesture, action, sound, word, visual imagery, arrangement of objects – are all born of the same mechanism, and that their origin displays a similar structure. The basic expression, insofar as it is not from the outset intended as communication, is a reflex. To what need, what bodily urge might it respond? … The genitals project onto the shoulders, the leg naturally projects onto the arm, the foot onto the hand, the toes onto the fingers. And so a strange hybrid is created, of the real and the virtual, of what is permitted and forbidden to each of the two elements, of which the one acquires such reality as the other has forfeited."

"The contrast is necessary in order for things to be and for a third reality to form."

Hans Bellmer

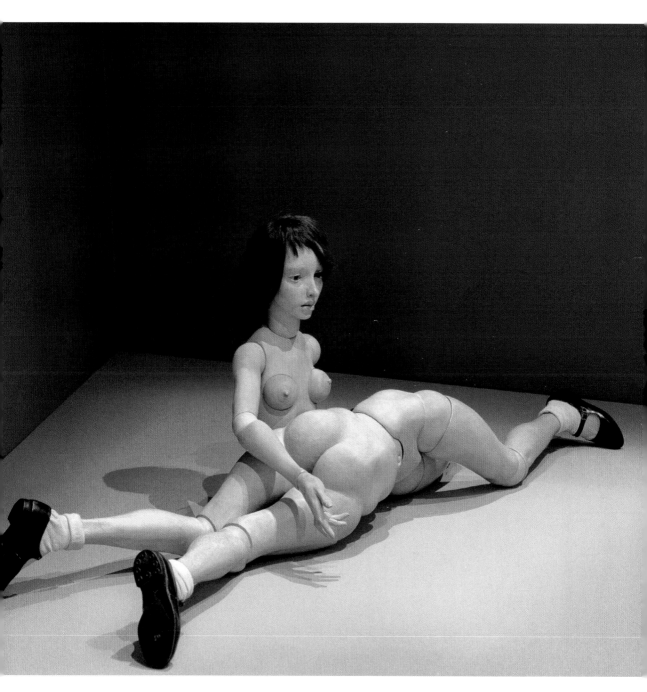

The wedding

Oil on canvas, 215 x 197 cm
Berlin, Neue Nationalgalerie

b. 1902 in Sagua la Grande (Cuba),
d. 1982 in Paris (France)

During the period following the Second World War when interest in the fantastic was gradually declining, Wifredo Lam's painting gave it new impetus. Lam, the son of a Chinese father and Cuban mother, at first attended the Escuela de Bellas Artes in Havana, before coming to Europe in the early 1920s. The decisive factor in his development as a painter was the period from 1938 to 1941 in Paris, where he formed a close liaison with Pablo Picasso. It also goes without saying that Lam fell under the spell of the Surrealists, whose interest in the supernatural, the irrational, and the magic fell on fertile ground with him. In addition he had an open mind where the Voodoo practices and other pagan-Christian mythologies of his Caribbean homeland were concerned.

The picture *The Wedding (Les noces)*, which dates from his fertile middle period, betrays the various influences both of the various cultural backgrounds and of the two mythic-religious spheres, Christianity and Voodoo. It reflects not only the painter's roots in Cuban culture but also his confrontation with the European avant-garde. This not altogether compatible conjunction creates a stimulus of its own and provides the key to understanding not only Lam's work but also how a quite individual form of the fantastical can result from this immanent incompatibility.

The title itself points to a union of man and woman generally or, in the metaphorical sense, of different views of the world. The solemn joining together in matrimony of two individuals creates a new community of interest and of creativity, which carries within itself the possibility of reproduction, of new life. For this reason we are not surprised to find that in almost all religions and cultures the foundation of this kind of community is formally marked by ritual and cultic actions.

The basic composition of this large-format picture has Cubist features in the form of its angular, zigzag and rounded shapes. There are three actors on this mysterious stage: on the left, a (presumably) masculine figure with a drawn sword in his hand, ready to jump, his head crowned with a two-headed beaked creature. To the right is a winged female figure with hooves, her hair in long waves flowing around a head which is formed by a large hollow. These two beings are being joined in matrimony by an apparition positioned in the middle, recognizable as female by her sexual characteristics. Her alignment is not clear. The "head" at the top is not human, while upside down in her abdomen is the small head of an Elegua – a friendly domestic spirit with two horns (whose gaze can place all evil forces under a magic spell and propitiate them by ceremonial sacrifices) – whose companions form the hem of her skirt. The whole apparition is balancing on a wheel and (with arms placed too low for the human anatomy) is imperiously handing the left-hand figure a weapon, and the right-hand figure a three-branched candlestick.

Technically, the depiction is completed by round and angular, short and long, large and small areas, in different shades of grey from light to dark; these all merge into an indefinable background of reddish, blue-tinged, and russet contours. The whole thing thus gives the impression of being in low relief, resembling the grotto of a natural shrine, in front of which secret cultic acts are to be performed. The fantastical aspect arises from the thus evoked magic, which can be related to the hinted-at contents as the directly comprehensible, primordial forms of matter.

The fantastical, primarily European in origin, is enriched in this picture by archaically significant archetypes of forms and rituals from the natural history of mankind.

> "when I was small, I was frightened of the power of my own imagination. ... I never saw any ghosts but I invented them. when I went for walks at night I was scared of the moon, the eye of the shadows. I felt I was an outsider, different from the rest. I don't know where it comes from. I have been like that since childhood."
>
> Wifredo Lam

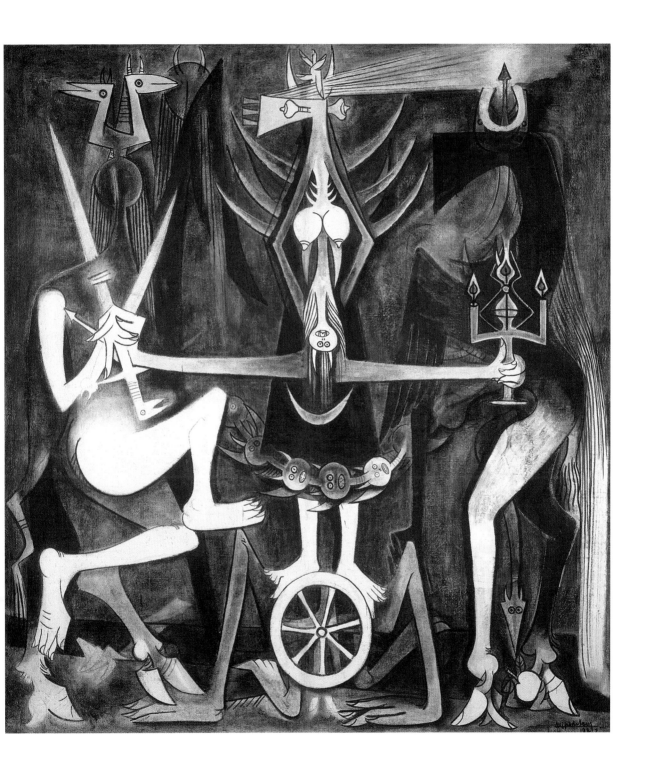

christina's world

Tempera on gesso panel, 81.9 x 121.3 cm
New York, The Museum of Modern Art

b. 1917 in Chadds Ford (USA)

Andrew Wyeth's pictures are a source of pleasure to a broad public, and his admirers call him a "painter for the people". In the opinion of some professional art critics, by contrast, he is almost only a talented illustrator. This is a phenomenon which is frequently seen in art, but in this case, it is particularly enlightening. As the youngest child of the painter N.C. Wyeth, he studied painting in his father's studio beginning at the age of 15; at 18 he became a full-time artist, and had his first exhibition, which was a great success, when he was 20.

His art, with what seem at first sight to be beautiful catchy pictures and archetypal views of a North American rural idyll which has probably never existed in reality, occupies a broad space in the country's collective memory, and is also well represented in museums and galleries. But in spite of, or precisely because of this, it is viewed with suspicion by art critics. With his pictures, Wyeth has created an inimitable myth and an individual, fantastical view of the continent's landscape. This can be seen as a projection surface for all the alleged dangers and shortcomings lurking in urban civilization, the classic counterpart to the simple life in the country. The unspoilt world of meadows and cornfields, of coarsely constructed wooden huts and tumbledown barns in East Coast villages is typical of the "land of the free, home of the brave".

One picture by this painter, who lived in the state of Maine for the whole of his life, is beyond all criticism: in *Christina's World*, his best-known work, the rural idyll is nothing but a beautiful illusion, a curtain draped across reality. The young woman, semi-recumbent in a sea of grass with her back turned to the beholder, looks relaxed, but only at first sight. She is some distance away from a makeshift track leading gently uphill to a house, to the left of which, at some distance, stands the farm's barn. One does not need to know that the woman is the crippled Christina Olson, a friend and neighbour of the Wyeths, to see that the distance between her and her home seems insuperably great.

The actual artistic charm of this picture lies in the painting and drawing technique. After many preliminary studies, Wyeth meticulously places on the canvas an agricultural view that anyone can understand. At the same time, however, this realism opens out into another plane, namely one in which things are overdrawn in a sophisticatedly illusionistic manner, because no matter how exactly the painter depicts the scene, he knows equally well that he cannot reproduce it perfectly. By depicting persons and things naturalistically, he simultaneously creates a foundation for a kind of viewing that wants to see this nature in quite a different light.

This ambivalence of the peaceful contemplative world is always there in Wyeth's art, and sublimely integrated with great skill. The beauty is for him a backcloth behind which reality can conceal itself. In brilliant pictures, Wyeth has reproduced the contradictions of his country – such as for example the fact that these unspoilt rural idylls have never existed. To reject its charm would mean rejecting a part of reality itself.

> **"in the portraits of that house, the windows are eyes or pieces of the soul, almost. тo me, each window is a different part of christina's life."**
>
> **Andrew Wyeth**

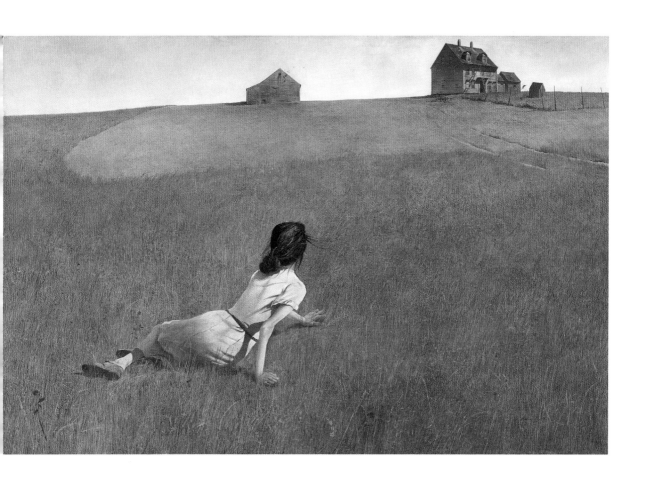

crucifix

Watercolour, 42 x 28.5 cm
Vienna, Peter Infeld Privatstiftung

b. 1930 in Vienna (Austria)

Ernst Fuchs, the one-time child-prodigy of the Vienna Fantastic Realists, has long since turned to other subjects than those he was interested in at the start of his artistic career. According to the perverse logic of the Nazis, Fuchs was a "1st degree half-caste": his father and grandfather were able to flee abroad. He himself underwent baptism in 1942 and just escaped the persecution of the Third Reich.

In 1945 he took up his studies at the Akademie der Bildenden Künste under Albert Paris Gütersloh and in 1948 was one of the co-founders, along with Wolfgang Hutter, Arik Brauer, Rudolf Hausner and Anton Lehmden, of the "Vienna School of Fantastic Realism". He achieved international recognition at an early stage, and lived in Paris from 1950 to 1962, where he made the acquaintance of Salvador Dalí among others, and developed a fascination for Europe's religious and mythological roots.

In his rediscovery of Christian themes, Fuchs does not proceed by scrutinizing and probing undemanding pastoral superficialities, but digs into the murky labyrinthine tangles resulting from religion, magic and myth. In the process, deep abysses open up before him, behind the ordinary ways of seeing. In this approach, a crucifixion is no longer just a tragic and inhumane-divine intermeshing of redemption and salvation, but a deeply demonic and baleful process, in which what happens borders on the obscene, the lascivious and the devilish.

The painting *Crucifix (Kruzifix)*, dating from 1950, shows the crucified Christ interpreted in a highly individual manner. He is depicted as an overlong figure apparently consisting of nothing but skin and bones. On his shrunken head, he is wearing an oversized bishop's mitre. The Mannerist overlong, bony legs, whose musculature looks more like a tattoo, and the matchstick-like arms are nailed to two thin, bent tree-trunks, whose lower ends reach down into a rectangular brick opening like the entrance to the underworld. Christ is flanked by two red kneeling creatures, of whom the one on the right – behind a communion chalice – looks like a praying jack-in-the-box, while the one on the left resembles a horned, lamb-headed but harmless hybrid between man and beast.

The eeriness of the whole composition is increased by the presence of two huge figures to the left and right of the crucified Christ. In Christian iconography, these were the Virgin Mary and St John the Apostle, but here we do not see the grieving witnesses of a redemption, but rather the embodiment of the horror depicted here. The figure on the right, whose head is far too small for the too tall body on which it is placed, is sunk in its own reverie, playing a turquoise mandolin-like instrument: a danse macabre to which the crucified figure also seems to be moving – a very peculiar kind of ecstasy. The left-hand angelic figure, beating a drum, is a winged hybrid creature consisting of feathers, death's heads, naked testicles and buttocks, and numerous shapeless cankers.

The immoral and blasphemous aspects of the scene lie not least in the suppositions to which the painting technique itself gives rise. For Fuchs has covered the picture with a number of very fine coats of varnish, which together evoke an infectious sparkle from the depths of the picture. The deliberate beauty of the painting technique casts a veil over what is depicted, preserving it from over-hasty interpretation and assessment. The enchanting coloration, which leads from a deep violet in the sky in the background via the lush green of the ground of an Arcadian landscape to the flaming orange of the kneeling figures, makes the contradictions within the fantastical calculation seem perfectly logical.

> **"The world of inner pictures, which often has little to do with impressions picked up by the physical eye from its surroundings, is also the space in which symbols are revealed and the space in which spirits and angels approach human beings."**
>
> **Ernst Fuchs**

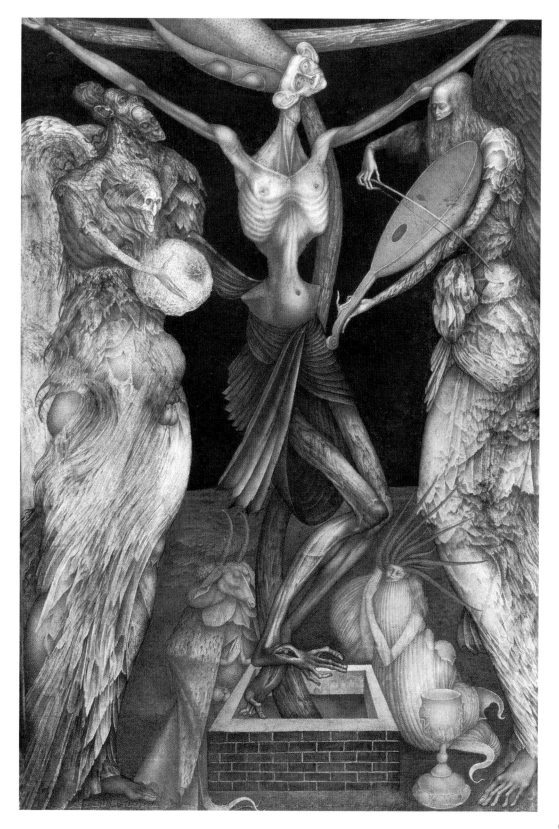

тhe тemptation of st аnthony

Ripolin and gloss-paint on hardboard, 121.8 x 91.3 cm
Melbourne, National Gallery of Victoria

**b. 1917 in Melbourne (Australia),
d. 1992 in London (Great Britain)**

Sidney Nolan is doubtless the best-known modern Australian painter, though his highly individual fantastical painting still has to be discovered by a broader public. Nolan has created in painting an autonomous mythology of the pioneering days of the European settlement of Australia, with figures such as the bushranger Ned Kelly, who was hanged in 1880 for theft and murder, and to whom he devoted a whole series of pictures, or outback paintings such as *Pretty Polly Mine,* the purchase of which in 1949 by the Art Gallery of New South Wales marked Nolan's first public recognition.

Trained in commercial graphics, Nolan was self-taught as an artist. From 1934 he attended the occasional art class at the National Gallery of Victoria, reading a great deal and trying his hand at painting in every available spare moment. In 1951 he travelled overseas for the first time, living in Cambridge, and visiting France, Spain, Portugal and Italy. In 1953 he returned to Europe permanently, settling in London in 1955. He was knighted in 1981 and made a member of Britain's exclusive Order of Merit two years later.

Nolan's *The Temptation of St Anthony* was inspired among other things by his study of the Italian art of the Renaissance. In the manner of Hieronymus Bosch, curious beings are placed in a landscape much scarred by crevices but otherwise unspoilt. St Anthony, the legendary hermit and founder of a colony of monks, is in the midst of a confrontation with these dangerous apparitions, who in Nolan's version are threatening him, rather than leading him into temptation. Contorting himself in Mannerist fashion, he is resisting the blandishments of a large lizard, which has crawled up behind him on its hind legs and inveigled itself as it were into his ear. Further dangers are lurking in the other direction. With his arms outstretched in fearful defence, he is warding off a giant dragonfly-like insect circling in the air in front of him, and opposite, a dwarfish female figure is stretching out in a temptingly indecent pose – remarkably, she has a halo.

The horizon is defined by a chain of low rocky hills, on which grow palm-trees that could have been folded from paper. In the light-blue, red-spotted sky an oversized hand appears top left: the hand of God, bidding peace to the scene. On the right a bearded devil is tumbling head first from the firmament, with a kind of olive-branch in his hands which could identify him as a fallen angel.

The main charm of this picture lies in the landscape. It comes across at first as a bucolic depiction varnished in the manner of the old masters, but the longer one looks at it, the more confusingly varied it becomes. Skilfully distributed optical illusions, such as the distorted scale of the trees in the foreground and background, hold our gaze and mislead it, which only serves to sensitise it for further details. In the process, this frequent motif of Christian iconography is transformed here into something new and surprising. Nolan has transferred a European subject into the broad unspoilt landscape of an almost uninhabited continent inhabited by natural creatures straight out of his imagination.

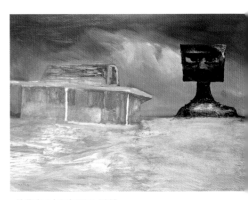

Kelly in a Landscape, 1969

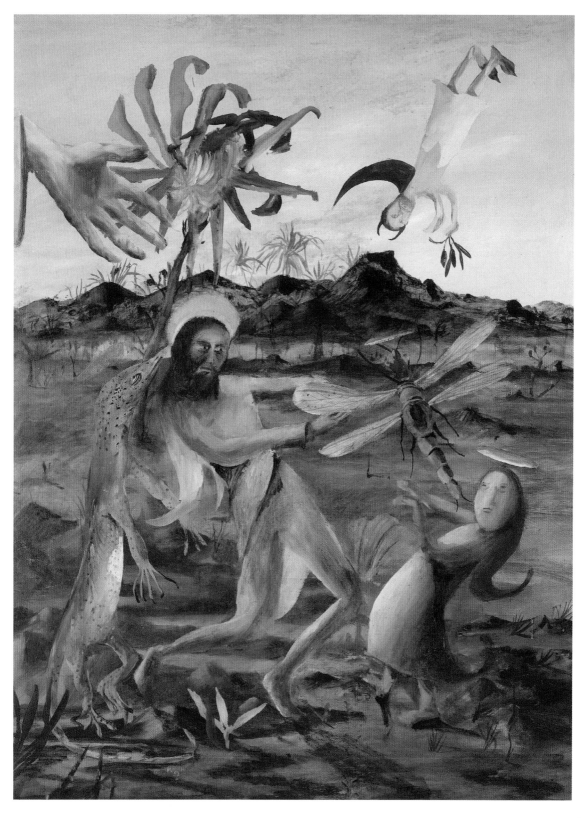

Nude Before a Mirror

Oil on canvas, 190.5 x 163.8 cm
New York, Metropolitan Museum of Art, Robert Lehman Collection, 1975

**b. 1908 in Paris (France),
d. 2001 in Rossinière (Switzerland)**

Balthus was born as Balthazar Klossowski de Rola, the second son of the art-historian and painter Erich Klossowski and the painter Elisabeth Dorothea Spiro, known as Baladine Klossowska. Throughout his life he declared that he had never ceased to see the world through the eyes of a child. He himself was against any interpretation of his pictures. He wanted them to be understood as still-lifes, and was perfectly ready to concede that his painting was concerned with a world which has no validity today. His oeuvre, limited both in style and in choice of motif, whose declared aim was beauty, dates back to when he was ten years old, when he produced a series of ink drawings of a cat which had first walked in on him and then walked out again, drawings which his friend and mentor Rainer Maria Rilke published in an album.

One of the visitors to his childhood home was the Fauvist painter André Derain, whose statement: "We only paint today in order to rediscover lost secrets" made a lasting impression on the young Balthus. Every single one of Balthus' pictures is a veritable treasure chamber, which the beholder dares to enter only hesitantly, looking around nervously for firm clues. In these premises one feels at first like a stranger, an intruder. Then, as in the picture *Nude before a Mirror* (also known as *Nude in front of a Mantel: Nu devant la cheminée)* the figures one finds there move like beings from another star, without time or space, without perceiving anything external they stand, lost in their dreams, withdrawn into themselves, in conversation at most with a cat or their own reflection. The naked girl in the picture is, for all her dreaminess, well aware of her own charisma. Thus the impression arises of a boudoir scene with the appropriate intimacies. It is the will of the artist that the beholder of this and other pictures, such as for example *The Room* (1947/48), which derive from the artist's deepest desires, should become a voyeur.

Balthus also painted landscapes, portraits, and still-lifes, but his preferred theme was the young girl, daydreaming, resting, sleeping, often naked or scantily clad. Whether these figures are "angels" or "Lolitas" lies in the eye of the beholder. Allegedly, Balthus was never able to understand the hoo-ha he caused with his naked nymphets, such as the one standing in front of the fireplace, because he always regarded his work as the portrayal of innocence: "I have only ever painted angels. And incidentally all my painting is religious."

Balthus, who never attended any academy, took as his role models the early-Renaissance painter Piero della Francesca and the Realist Gustave Courbet, borrowing composition schemas, for instance, from both. And yet Balthus gives his seemingly banal, precisely executed pictures an irrational dream effect, which, deriving from the contrasting attitude of the variously stylised figures and from a glimmer of demonic tension, makes them worthy of the description "fantastic".

"Balthus is a painter of whom nothing is known. Now let us look at the pictures."

Balthus

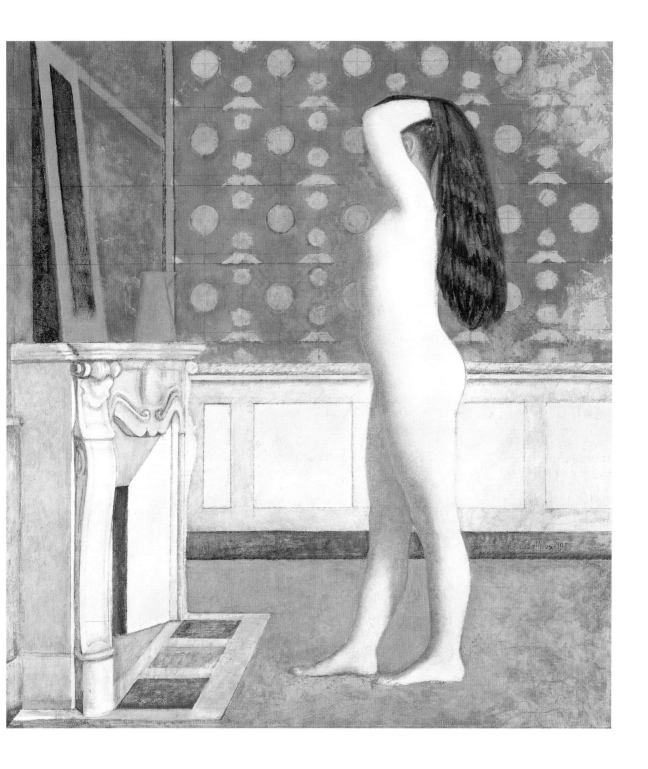

passage to Etna

Oil on canvas, 198.12 x 98.11 cm
Boston, Harvard University Art Museums – The Fogg Art Museum

**b. 1906 in Smorgon (Russia),
d. 1992 in Sherman (USA)**

Peter Blume was one of North America's few fantastical painters. In the land of proverbially everyday and philosophical pragmatism, there seems to be little scope for such a flower to blossom. The artist was born in what is now Belarus and as a child was taken by his parents to the United States, where as a teenager he studied at the Educational Alliance Art School before moving on to the Art Students League and the Beaux-Arts Academy in New York. Only after a long sojourn in Europe during the 1940s did he develop his markedly fantastical style.

In contrast to what we might be led to expect by the title, his picture *Passage to Etna* only indirectly recalls the impressions of the years he spent travelling in Italy. What is depicted, rather, is an artificial-looking townscape, the location of which remains unclear. Only the fragments of a number of ancient columns, arranged in a tidy triangular heap occupying the entire foreground, point to classical Italy. They may provide a clue to the location mentioned in the title, perhaps a town at the foot of the volcano Mount Etna in Sicily. The ruins are piled up in shallow water, maybe part of a sewer or drain, and they are surrounded by grave niches, in which skeletons lie.

The conical Mount Etna with the characteristic plume of smoke hanging over its crater is not itself to be seen; there is only the smoke, emerging from a small chimney of a house, to remind us of the volcano. The excessively long clothes-lines, by contrast, fastened zigzag to the building facades from the centre of the picture and reaching into its distant background, are nonetheless unambiguously Mediterranean. From them hang shirts and other clothes in a variety of pastel shades, airy and comical, while a dark-haired beauty on a narrow balcony is in the process of seeing to another item of washing.

On a bridge next to the ancient ruins stands a group of male figures of all ages, from boys to old men. They are standing around, walking up and down, looking over the balustrade, talking to each other, or gesticulating wildly. In the background of this collection of people we can see further individuals in the openings formed by three high windows, which, not altogether typical of southern Italy, are topped by round sandstone arches. Above them, two ladies on a balcony are looking down with interest at the men below; a small child, unconcerned with anything else, is holding his arms in the air.

In spite of the human figures, the scene comes across as curiously empty of people. The townscape actually consists of a rising path which is differently foreshortened by perspective at different heights, winding its way from the ancient rubble foreground, which comes across as too large, to distant, undefinable heights. The bends in the path are hinted at by the clothes waving in the breeze on the line, but there is no hint of the physical effort involved in a real climb.

The charm of this picture with all its details lies however in the depiction itself. The curiously unreal graduations of colour, which are harmonious in themselves, the sophisticated treatment of the architecture, and the playful construction of familiar objects in a surprising context add up to a unique scenario of altogether childlike ideas of what constitutes a Mediterranean idyll. A yearning for this idyll forms the intellectual foundation of the latent fantastical component.

Vegetable Dinner, 1927

All the Lights

Oil on canvas, 150 x 130 cm
Saint-Idesbald, Fondation Paul Delvaux

b. 1897 in Antheit (Belgium),
d. 1994 in Furnes

Many elements of the fantastical are assembled in this late work by Paul Delvaux: the vague content, the diffuse arrangement of objects, the unreal figures, the carefully attuned colours, the indirect lighting, and even the title *All the Lights (Toutes les lumières)* seems designed to pull the wool over the beholder's eyes. The fact that compared with many other fantastic pictures it has not attracted the attention it deserves may be due to the personality of the painter, who did not enjoy the limelight, preferring to lead a quiet life.

Like his great compatriot René Magritte, Delvaux created his oeuvre well out of the public eye. He studied at the Académie des Beaux-Arts in Brussels, but in the late 1920s broke away from traditional role models after attending an exhibition of the work of Giorgio de Chirico in Paris and making the acquaintance of Magritte not long after.

The picture's magic derives first and foremost from its ambivalent atmosphere. The beholder can immerse himself in it for hours, discovering the many things there are to be seen, without ever getting to the bottom of all its secrets. Rather, they will run up against the curious paradox of the fantastical, namely, that the more they look, the less they will recognize. This is due above all to the lighting situation, which is impossible to understand. Although "all the lights" are lit, there is no way of knowing what their source is or what they are supposed to be illuminating.

First of all there are the two street lamps, casting their cones of light downwards like spotlights, and lighting up a street. Then there are the lighted windows on the side of a well-to-do house in a suburb of a Belgian town, which even give us a few peeks into the interiors of individual rooms. In the road there stand six paraffin lamps, which, strongly foreshortened by perspective, draw the beholder's gaze directly downwards. The street itself consists in the centre of light cobblestones, with brown stone slabs on either side, the sign of an upper-middle-class neighbourhood. In the sky the thin crescent of a waxing moon can be seen between the bare branches of large trees, and a few stars are twinkling. Apart from the glow of the lights from a town on the horizon, everything else is dark, only a wall to the left and a stone plinth reflect some of the ambient brightness.

The light of the street-lamp nearest us falls onto a delicate female figure who casts a long shadow as she moves statue-like towards the beholder with her arms held at a peculiar angle. A second figure, apparently identical, but with her back turned to the beholder, is hurrying away in the distance. Apart from these two women, atypically dressed in long white lace dresses, who come across like porcelain figurines, there is not a soul to be seen. Only the detailed interiors behind the lighted windows give any hint that people might live there. But that too is uncertain.

The ambiguity of the whole scene suggests to the beholder that he or she is watching a piece of theatre of the absurd. Nothing seems to be what it appears, and nothing appears as it ought to be. Everything here is seen emerging from the shadows cast by the lights, only to disappear into the darkness once more. The absence of people who actually belong in this lovingly arranged scene is not compensated for by the presence of two self-absorbed, delicate, female figures, who in fact merely underline the puzzling atmosphere. This picture is fantastical in that it conveys the unresolvable mystery of an inexplicable void.

"In an atmosphere of mystical lasciviousness, living waxworks with wide-open shadow eyes pass through the imaginary landscape.
… A macabre world of nightmares, of suppressed urges, of middle-class boredom, of hopeless loneliness, and of hypnotic sleep from which there is no awakening."

Oto Bihalji-Merin

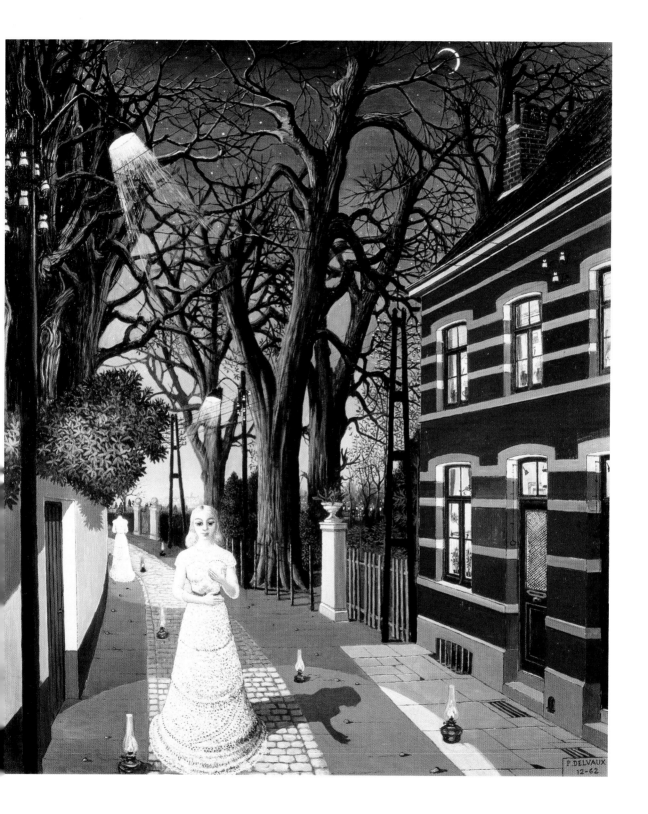

The presences

Oil on wood, 120 x 120 cm
Bologna, Galleria Forni collection

b. 1913 in Milan (Italy),
d. 1993 in Rome

The fantastic art of Fabrizio Clerici has led a somewhat shadowy existence in the modern art movement, and yet he continued the tradition both of Surrealism and of Fantastic Art, developing it and giving it his own very individual formal impulses and content focuses. In his pictures we can discover a fantasy whose austerity and conciseness is without parallel. It does not concentrate on the darkly mysterious, the mythically mystical, the esoteric and the weird, but on visions of collapse, depicted in a cool and objective manner.

Clerici, who trained in Rome as an architect, was a painter, graphic artist, stage-set designer (for, among others, Giorgio Strehler and Jean Cocteau), collector, explorer and literary connoisseur. Often, he compiles ruinous townscapes from classical, medieval and oriental set-pieces: nightmares of urban civilization. The Franco-American writer Julien Green admits that standing in front of Clerici's pictures, he had often asked himself "how, with such delicate means, he was able to express the anguish of fear that we all feel in the face of today's world. … It is one of the most beautiful dreams of today's world-angst melancholy."

In *The Presences (Le presenze)* Clerici paraphrases Arnold Böcklin's famous *Island of the Dead*, albeit not by exaggerating it (in the way that some artists seek to outdo their venerated model and in doing so, ultimately "paint them dead"). Clerici, who as an Italian wanted to create an affinity with Böcklin, who had chosen to live in Florence, takes a different approach rather than trying to outpaint him. He constructs a sophisticatedly staggered stage, on which he plays with his role model's set pieces by trying out a number of different positions. Clerici subjects his model to questioning of a totally new kind, and seeks to discover which of his illusions are still usable and in decent condition, thereby discovering surprising views and characteristics. Looked at in the light, the various details of the elegiacally crepuscular island seem to contain qualities which have been hitherto overlooked. Thus individual details appear, used either as a stage backcloth or else anchored in the ground as sculptures. They take on various roles in a performance, in which Europe replays its own existence and continually asks questions of itself.

The island of death, of final rest and of unquenchable desire is brightly illuminated by Clerici, so that its daylight sides awaken, and we do not just see its slumbering night side. He depicts a place of yearning, but for life, for continued existence, for survival, and not for transience and death: a place of arrival, not of leave-taking.

The fantastical in this artist's work is consummated in the light of the Mediterranean sun, beneath which there is just as much to surprise us as there is in Böcklin's eerie murk. Clerici shows the beholder that he or she need no longer shiver in the presence of the *Island of the Dead*, but feel comfortable and relaxed.

> **"The mysterious struggle between delicious artificiality and rough reality is underlined by his stage sets and costume designs without any use ever being made of symbols. Is clerici therefore not a prince of that fantastic realism which put its stamp on the 20th century? … His ink has something of the slow black current of the river of the dead."**
>
> **Jean Cocteau**

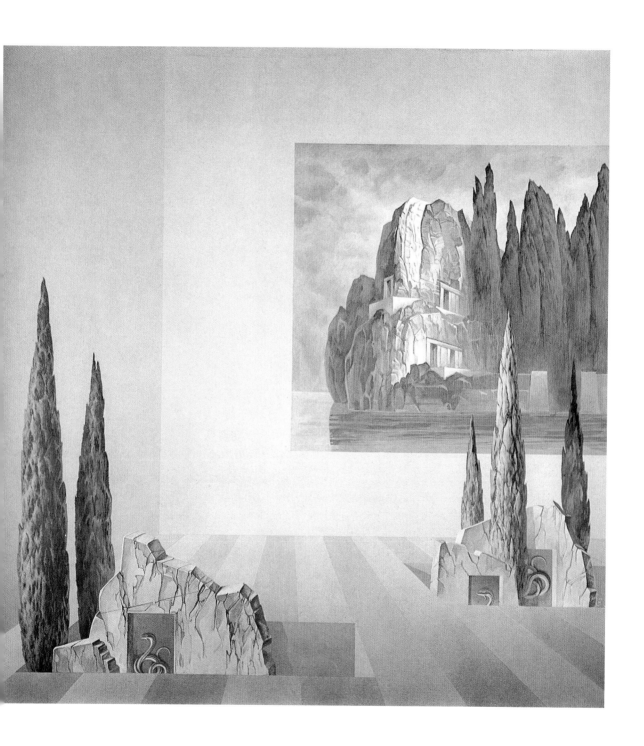

тhe House of Raquel vega

Oil on canvas, 195.5 x 246.5 cm
Vienna, Museum Moderner Kunst, Stiftung Ludwig

b. 1932 in Medellín (Colombia)

Adam and Eve have not yet been expelled from Fernando Botero's paradise. His pictorial world is populated by cosy creatures in a state of pure innocence. His is a truly fantastical universe of incomparable figures. "I don't paint fat people," replies Botero when asked why he does. A second glance at his pictures shows that everything else is "fat" too: the fruit, the animals and even the houses. By transforming or deforming it, he translates reality into art. Or, in Botero's words: "Art is always an exaggeration of reality, its colour, its shape, its spiritual meaning."

Botero had no formal training; he began to draw at an early age and, self-taught, had his first exhibition at the age of 19. His knowledge of painting was derived from books and reproductions. In 1952, he set off for Europe, first to Madrid, then Paris; he visited the Prado and the Louvre, occasionally enrolled at an academy, for example in Florence to study fresco techniques. Since 1960 he has been resident in New York, since 1971 also in Paris.

In his picture *The House of Raquel Vega (La casa de Raquel Vega)* a few imposing figures are assembled. The ladies are dressed somewhat scantily, while the men have loosened their ties and are drinking straight from the bottle. They seem to be enjoying themselves, the dim light from the coloured light-bulbs creating an appropriate atmosphere, and it is in this situation that the assembled figures are posing happily for a group photo with children and pets. That the picture is set in an establishment in the notorious city of Medellín in Colombia not only adds a frisson of excitement, but also increases the pleasure involved. In Botero's youth, Medellín was best known for its red-light district. Decades later, from distant New York or Paris, he has memorialised this milieu in this picture.

Brothel scenes such as this one, or the one portrayed in *The House of Amanda Ramírez* (1988) are among the most sensuous and risqué in Botero's oeuvre. The mood comes across as solemn rather than physical, however, and sex is never a foreground theme. They are more reticent than the depictions of brothels in the works of Toulouse-Lautrec, the German Expressionists, or naturally Picasso, who supplied the most famous interpretation of all, *Les Demoiselles d'Avignon* (1907).

Botero, the magician from a country which always knows how to stimulate our fantasy, has created with his groups of real individuals a universe that shines like a mirror. With a magnificently old-masterly technique, he unfolds a panorama of absurdly charming figures devoid of all proportion. His exaggerated volumes are a magic wand with which he transforms the world and the life in it into floating unreality.

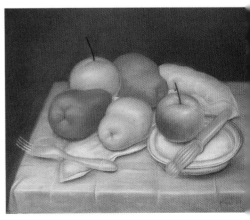

Fruits, 1969

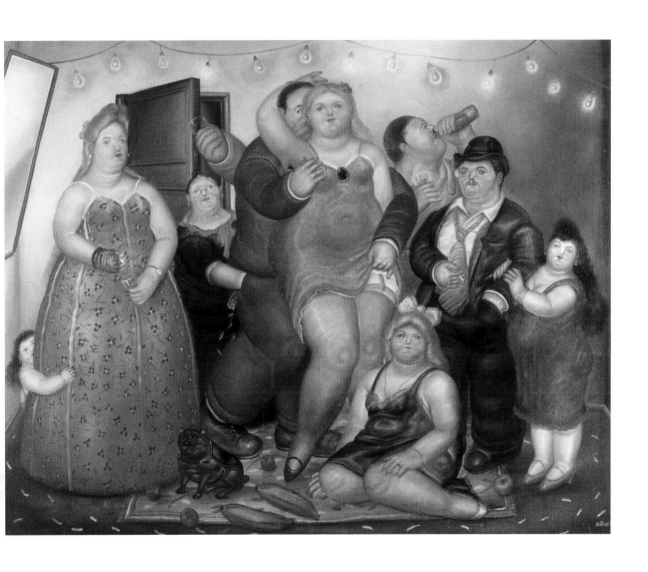

The End of the Jurisdiction of Fools

Mixed techniques on wood, 88.5 x 70 cm
Bad Frankenhausen, Panorama Museum

**b. 1929 in Schönebeck (Germany),
d. 2004 in Leipzig**

Werner Tübke occupied a central role in the German art scene of the second half of the 20th century, albeit a role not free from contradictions. As a leading painter in communist East Germany – he was one of the so-called Gang of Four, along with Willi Sitte, Bernhard Heisig and Wolfgang Mattheuer – he kept silence on many topics discussed in private or public; as a wanderer between the political systems, he had to be careful to maintain a balance. After re-unification, he was seen on the one hand as a pioneer of figuratively sophisticated fantastic art, and on the other, celebrated or denigrated as the case may be, as a hero of Socialist Realism.

In his pictures Tübke discovered a style which, while based in the tradition of European art over the last half millennium, continued to develop and, with a strictly-defined focus in respect of content, evinced an individual view of things. His showpiece is the huge (more than 1,700 square metres in area) Peasants' War panorama *Early Bourgeois Revolution in Germany*, dating from 1976–1987, in the Thuringian town of Bad Frankenhausen.

On closer inspection of his pictures, we are surprised by the consistency with which he aims at, pursues and attains his goals. When Tübke, for example, turns to the tradition and history of the administration of justice, in the process emphasizing the function of "fools" and the so-called freedom of the court jester, then the different aspects come at us in a rush and yield up strange sights. While preparing the Peasants' War panorama, Tübke investigated the social structures of the period, questions of church history, Roman Law, the cult of demons, and witchcraft. These influences are also reflected in the picture *The End of the Jurisdiction of Fools (Ende der Narrengerichtsbarkeit)*, for example in the use of symbols, thought to have been pretty hackneyed, of the different areas of domination such as church and state. Before the eyes of astonished contemporaries

appears the reality of a time long past. The seductive mix of his palette and his amazingly confident draughtsmanship allow Tübke to unfold a lively scene full of splendour.

It was for this reason that Eduard Beaucamp, the former critic for the Frankfurter Allgemeine Zeitung newspaper, who was always well disposed towards Tübke, called him a "great unmodern": "What the present-day denies us in respect of meaning, humanity and the ideal, Tübke borrows from classical and Christian morality. In this one might see an ennoblement of an East German reality that is anything but humane, but also a warning, a contradiction, indeed an invocation of opposites."

With skilfully deployed set-pieces of history, with overt and covert hints of all kinds, and with a highly professional game using marked cards, Tübke creates a situation in which beholders can stroll around to their hearts' content and lose themselves in the wings of very differently staged plays. Tübke performs a world drama whose protagonists are costumed apparitions, homeless people, beggars and others who have lost out in life, but also harlequins, acrobats, commedia-dell'arte figures and professional fools.

It is an open question whether this is the start of a new state in which the laws are set up according to different principles of justice and equality. In any case, Tübke made use of the fantastic in order to convince himself and us of the rich variety which characterizes all our lives – in all ages and in all circumstances. For the Peasants' War panorama, Tübke himself formulated his goal as to exert "the highest-possible magical effect on the beholder".

"Today it seems important to me to possess the capacity for utopia, including the capacity for utopia backwards."

Werner Tübke

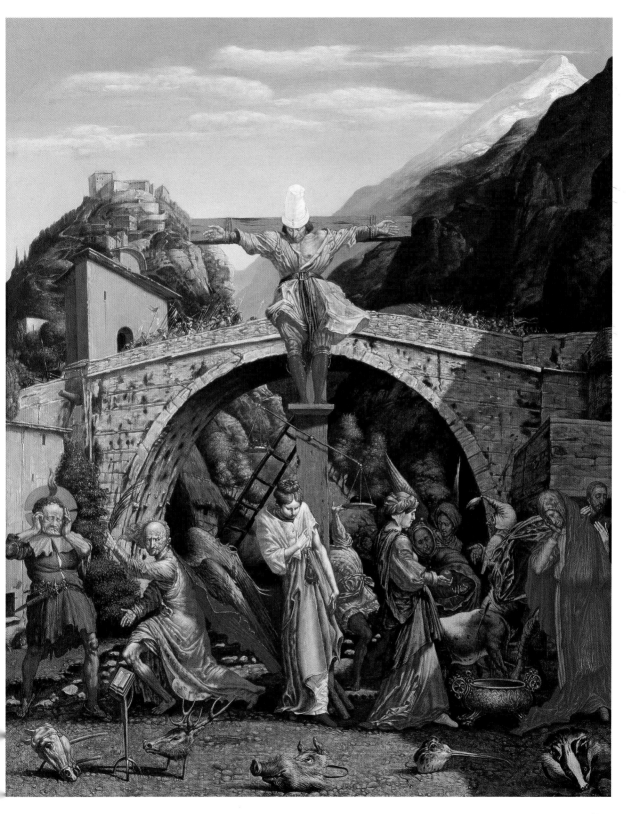

Biomechanical Mia, Egyptian-style

Acrylic on paper, 70 x 70 cm
Vienna, Roman Fuchs collection

b. 1940 in Chur (Switzerland)

A trained designer (he studied interior decoration and industrial design at the Kunstgewerbeschule in Zurich), HR Giger sets the devil loose on the fantastical scene. In 1980, he was awarded an Oscar for the visual effects in Ridley Scott's 1978 science-fiction horror film "Alien", thus showing himself once more to be a Swiss Beelzebub. However you turn his work around to look at it, Giger is primarily concerned with the pit: he has opened the gates of the underworld and the spirits which he has conjured up on the canvas will leave neither him nor us. He has, if you like, brought the unconscious to the world of art, for suppressed images, as we know, are the ones that stick longest in the memory, where they continue to lead a life of their own.

The pictures with which Giger has familiarized us are not visually attractive, but they are true. In this work on paper, *Biomechanical Mia, Egyptian-style (Mia biomechanisch-ägyptisch)*, which is representative of Giger's art, all the bodily orifices of a faultlessly slim young woman are attached via tubes, wires, pipes and other technical facilities to various devices, machines and appliances. Biological life seems to have departed from her body. Instead, it is by artificial means that she is respirated and provided with all necessary life-supporting substances and measures. This woman has lost the individuality which characterizes every human being and makes him or her inimitably what he or she is. She is already an integral part of the determining mechanisms of a technically managed world. The "Mia" in the title of the work refers to Mia Bonzanigo, to whom Giger was briefly married around 1980. The "Egyptian-style" is a misleading and at the same time illuminating reminiscence of a distant past which has long since sunk into oblivion. The metallic bandages around her body are reminiscent of an ancient Egyptian mummy, whose embalmed contents we can no longer recognize as an individual.

Giger's figures, who are being artificially kept alive, inhabit a world grown cold, which, while it is technically perfect and works faultlessly, is also free of human beings with their characteristic natural imperfections. In spite of the clearly palpable coldness, Giger's pictures are fascinating on account of their brilliance and purposefulness: the glittering façade of progress which has always dazzled people, but which at times they also see as a premonition of their decline and fall. For human beings are the only species that seems to have any inkling of its own end, of death, an inkling that constantly frightens and paralyses them, but also drives and motivates them to seek antidotes – one of which is art itself.

Giger's depictions of a distant, alien and yet so present world are like sonorous messages of a supernatural promise. The fear immanent in them, which sends a shiver down our backs, is the psycho-aesthetic lubricant that drives and characterizes this art. In addition, the lurking dangers are expressed in such beguiling imagery and such enchanting colours that the terror and horror immediately evaporate. But even so, we cannot apply the old proverb "A danger foreseen is half avoided", because the aliens are probably already among us. Thanks to Giger's irresistibly attractive and at the same time repellent portraits, we can at least confront them with our eyes open.

> **"By 'biomechanoids' I understood a harmonious fusion of mechanical technology with the organism. genetic research will yet teach us the meaning of fear."**
>
> **HR Giger**

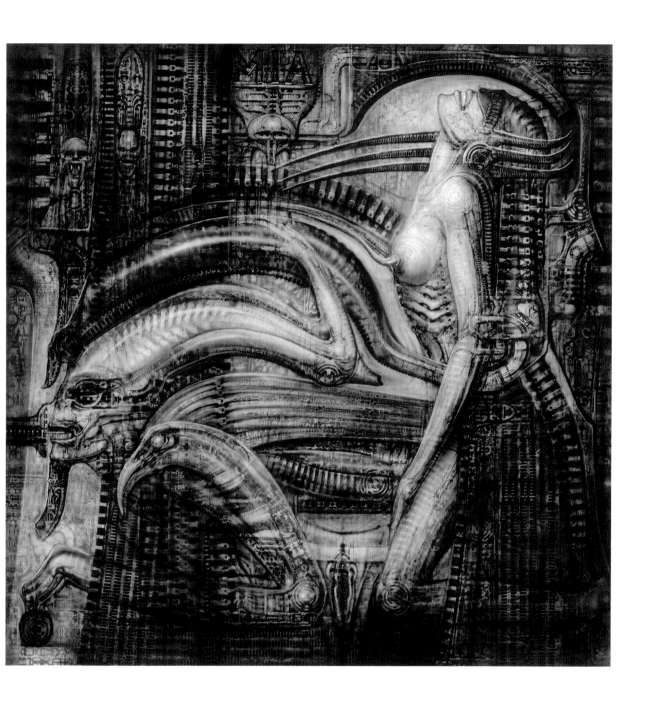

adam moderate

Acrylic, resin oil varnishes on canvas, 74 x 76 cm
Private collection

b. 1914 in Vienna (Austria),
d. 1994 in Mödling

Rudolf Hausner, the most austere and, psychologically, the most productive of the Vienna Fantastic Realist group, has, with his various depictions of *Adam* – e.g. *Adam in the Mirror, Adam's Tree of Life*, *Adam is the Measure*, *Adam Classified* – created a singularly condensed archetype of his age. It unites the self-portrait and characters from mythology like Odysseus, Oedipus and Anima in different proportions, and together they produce the complex matrix of a person. Proceeding from the *Ark of Odysseus* (1948–1956), a truly archetypal depiction of an era, right through to his final pictures in the early 1990s, Hausner worked on the increasing specificity of this pictorial statement.

Hausner studied at the Akademie der Bildenden Künste in Vienna and in 1938 was declared a "degenerate artist" and forbidden to exhibit. In 1946, together with Edgar Jené, Ernst Fuchs, Wolfgang Hutter and Fritz Janschka, he founded a Surrealist group in the Austrian Art Club, which was later joined by Anton Lehmden and Arik Brauer, and which was to give rise to what Johann Muschik christened the "Vienna School of Fantastic Realism". For all the fantasy of the contents of their pictures, the Vienna Realists, unlike the Surrealists, emphasized a certain role for rational thought in the creative process.

The painting *Adam Moderate* or – the German title *Adam Massvoll* can be read as a pun – *Adam Full of Measures* constitutes a kind of cross sum of Hausner's lifelong endeavour: an infectious painting construct in a small well-considered selection of colours with precisely graded degrees of brightness and saturation. In a russet border we see an almost square section of blue sky, and beneath it a long narrow stripe of saturated green. This backdrop of artificially cleansed nature is further subdivided, however, by a further rectangular frame of equal-sized yellowish-red elements. Inside this we see –

shifted away from the geometric centre – the imposing head of a mature Adam.

Unlike other "measured out" Adam figures that Hausner surrounded with metric references such as measuring rods, brackets, and alignments, this Adam is presented frontally to the beholder, naked and unprotected, and without the usual distinguishing marks or status symbols of a modern individual. *Adam Moderate* gazes at the beholder directly at eye-level: he has aged, his facial features are hollow and wrinkled; he is a Methuselah in an era which worships at the altar of youth.

This Adam represents a kind of aesthetic summing-up. He has reflected on himself, his development and his aging process as the measure of all things, and can thus as a free subject, uninfluenced by current fashions, self-confidently hold up a mirror to the beholder, who is equally free to take up the offer. It is in this encounter that Hausner's fantastical notion lies, namely to accompany the beholder in his or her own search for him or herself.

"All the Adam pictures are mirror images. They were painted with the help of a mirror and want to be used like a mirror. Although all the Adam pictures bear the features of Rudolf Hausner, their applicability for purposes of self-recognition is not limited to him alone; rather, all the Adam situations depicted are of an altogether universal nature."

Rudolf Hausner

R. Heusner 93

great Deeds Against the Dead

Fibreglass, artificial resin, paint, artificial hair, 277 x 244 x 152 cm
London, The Saatchi Gallery

Dinos b. 1962 in London (Great Britain), Jake b. 1966 in Cheltenham (Great Britain)

It is only at first fleeting sight that the sculptures of Jake and Dinos Chapman come across as images of normal people. When we look a second time, we are confused by their physical oddities, anomalies and deformities. These figures from the chamber of horrors of human imagination are designed to make all previous images look permanently harmless. Everything possible in the imagination is represented by these figures as monstrous but real. The perverted nature of these images gives birth to the monsters that slumber within all of us. With their scenarios which are as shocking as they are provocative, they are among the "Young British Artist" protégés of the advertising mogul Charles Saatchi.

With their installation *Great Deeds Against the Dead*, however, the artists have given the screw of macabre fascination a new twist. Formally, their work is a fairly literal rendition of sheet 39 of Francisco de Goya's *Horrors of War* (c. 1810/11), in which the Spanish painter reflected on the effects of Napoleon's occupation of Spain. In 2003 the Chapmans went as far as to acquire a complete set of the etchings, and to "rework and improve" *(Goya Reworked and Improved)* them, a much-debated procedure.

Using the imagery of the crucifixion story, the Chapman brothers present three human bodies cast from artificial resin. While the main "Christ" figure is tied to a tree-trunk, behind which a further body can be seen hanging upside-down (whom one could interpret as a premonition of St Peter's later crucifixion in this manner), the third member of the trio has been dismembered before being attached to the branch reaching out to the right: the torso is hanging upside down by its legs, the head has been impaled further along, while the arms, still chained at the wrists, are suspended separately. The figures are presented as androgynous graceful youths with faultless bodies, the style of their jet-black hair strongly resembling that of the Chapman brothers. All three have been castrated. At this point the installation, which superficially could be seen as no more than a mere pop-art provocation, becomes something more ambivalent, more religious.

For the Christian event which is being quoted here is ultimately just as ambivalent and magnificently disturbing, in other words a narrative in contradictory pictorial scenes. Its theme is the incarnation of the son of God. In the tradition of the Church, however, this essential criterion is continually being denied or hidden. For Christ could be everything: redeemer, miracle healer, silent sufferer – but the one thing he was not allowed to be was a man. In the course of Western art history, his sexual organs have been continually covered up or painted over. That the present artists now wanted to break unambiguously with this centuries-long pretence by cutting off their biological masculine identity thus seems only logical.

The art of the Chapman brothers is fantastic in the sense that it shows up precisely these critical points, as in the course of history lies, fairy-tales, and all sorts of legends have been added on to the truth and hence have distorted it. The artists however are not presenting religion as a camouflage of a higher truth; but rather, using the cunning of the fantastic, they are taking the dogma of the Christian religion seriously, indeed literally. This dilemma of Christianity could not have been presented more fittingly or in a more lastingly disturbing manner.

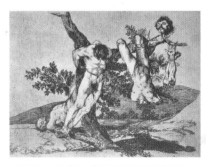

Francisco de Goya, Great Deeds! With Dead Men!, c. 1810/11

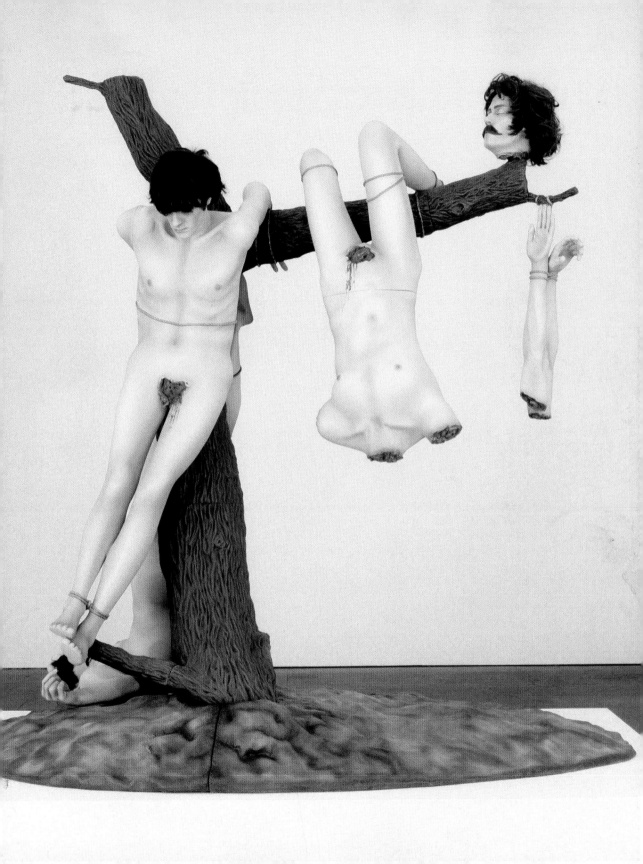

The Ninth Hour

Mixed media, variable dimensions
Private collection

b. 1960 in Padua (Italy)

Is the Italian artist Maurizio Cattelan launching a major attack against the helpless Holy Father? Is he placing an ironic exclamation mark or simply committing downright blasphemy? Not at all! *The Ninth Hour (La nona ora)* is, rather, a work of art that, while it provokes, is also brilliant in form and unambiguously contemporary in the sense that it takes up a definite position vis-à-vis the present. The Pope, the head of a global faith community, who is continually undertaking missionary journeys to the whole world, must be able to tolerate being artistically played with, portrayed and also judged.

The fact that in the process the story of the Passion of Christ is quoted, according to which at the ninth hour the crucified Son of God experienced a moment of doubt (My God, my God, why hast thou forsaken me?), has after all for centuries given cause enough to form one's own thoughts on this story, including thoughts that could be put into pictorial form. The result to which Cattelan comes is literally "in your face": shocking and direct. The Pope is felled by a meteorite. Any beholder, whatever their attitude to the Roman Catholic faith, can understand the depicted incident directly and without explanation. Fundamental questions are thrown up: what about the papal claim to infallibility, when the Pope is not even safe from events like this? Is even the Vicar of Christ on Earth not safe from the results of unpredictable chance? Who is going to be the victim of fate, and where? For example in the possible, albeit unlikely, form of being struck by an impacting meteorite, a natural event after all.

In self-assured fashion, Cattelan is proud of being the joker in the current art pack. Self-taught, he sets out the concept and leaves the execution to others. Quite rightly he occupies a central place in contemporary art. This is due on the one hand to the remarkable accuracy with which he has touched a contemporary nerve, with which he shakes taboos, and with which he knows how to give appropriate form to an idea. At the same time he embodies the archetype of the intrepid artist, who does not shrink back in the face of the powers that be, and who confronts the challenges that face a contemporary artist.

Cattelan is a fantastical artist to the extent that his art is captivating as a result of its critically tinged aloofness from the many cheap products on the art market. In opposition to this streamlined orientation towards success, Cattelan sets up his churning installations, which captivate us with the wit with which they are conceived, the seriousness which they radiate, and the skill with which they are executed. In its vehemence, the work jumps out at the beholder and demands a specific opinion. Cattelan's fallen hero wants not only our sympathy, but above all our decision, our judgement, and without regard for loss. More can hardly be asked of art.

Love Lasts Forever, 1997

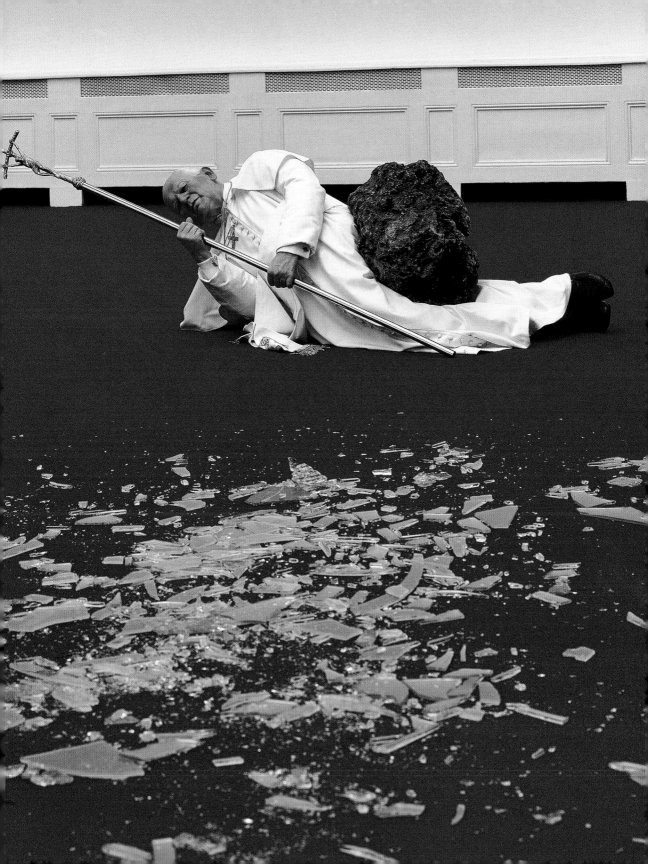

Big Family Picture No. 1

Oil on canvas, 200 x 300 cm
In the artist's possession

b. 1958 in Kunming (China)

This excursion into the far-flung realm of the fantastic is coming to a close with a look into the faces of a family from present-day China, faces which respond coolly and unmovingly to the gaze of the beholder. While our initial interest was directed towards the mythical, historical and cultural actualities which in the course of the history of art have attracted the attention of artists to the fantastic, since Freud's discovery of psychoanalysis at the beginning of the 20th century people themselves, their personas, their souls and their behaviour have become the object of art. This is also true of their physiognomy, their unfathomable faces with their play of expressions and mimetic variety as the visible reflection of their interior.

The pictures of Zhang Xiaogang, a modern Chinese painter, are a good example. After finishing his studies, the artist turned, in the picture cycles *Big Family* or *Bloodlines*, to his own family history as representative of all others. Using old photographs, for example from the period of the baleful Cultural Revolution, he got to know his forebears. In the process, he made the curious discovery that people have a protective mechanism in the form of an ability to pretend. The more the individual can hide behind a façade he or she has set up, the easier it is to develop inwardly – and thus to withdraw from numerous external influences, for example the obligation to collectivise.

The family in his strikingly staged *Family Picture* consists of three members: father, mother, child. In today's China with its one-child policy more than anywhere else, this nuclear family has taken the place of the extended family. As a result, it has gained in emotional closeness, but lost in terms of demarcation towards the outside. All three persons present a mask to the beholder on which there is nothing individual to be discerned. As a small group, they put across an image of closed-ranks, linked by the delicate red lines of a blood relationship. Thus father, mother and child coagulate into their own stereotypes. This family has fossilized into a memorial to itself. It is nothing but a template, a two-dimensional silhouette. The immobility changes, after one has looked long enough, into an exaggeration of the obsolete institution, the family. The harmonious unity turns out to be a chimera. The bon mot of Karl Kraus: "The expression 'family gang' has a flavour of truth", takes on a durable meaning here.

And indeed the age of the family (an institution with, factually, a relatively short history) seems to be over. New living arrangements are taking its place. Zhang Xiaogang's striking portrait of the family comes across even now as a memorial to it.

A picture like this raises the fantastic to a different level by targeting the individual, who still has to be discovered in China. The fantastical, which previously devoted itself to esoteric, weird, sublime and elegant themes and people, has found a new field of activity. Its former contents have been consigned irrevocably to history. By turning to the human being as a still relatively unfathomed being, it can plumb his or her depths. There is enough new to explore here, and not just in the Europe and the rest of the Western world that we are used to, but anytime and anywhere.

> "we live in a big family, the first thing we learn is how to shut ourselves up in a secret small cell and pretend to keep step with all the other members of the family."
>
> **Zhang Xiaogang**

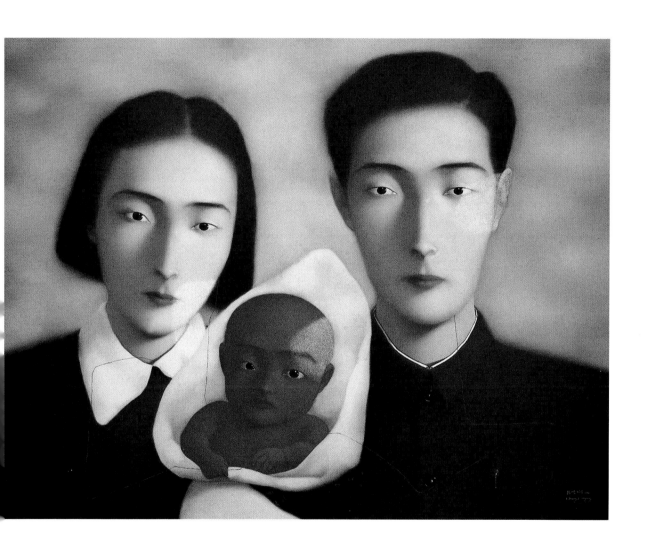

pelican (stag)

Oil on canvas, 275.2 x 200 cm
Courtesy Contemporary Fine Arts, Berlin

**b. 1959 in Edinburgh
(Great Britain)**

In the work of Peter Doig, the fantastic tradition in art which saw itself as primarily linked to nature comes full circle, for the time being at least. It is no longer human beings who are the selected subject of his art, but the environment. The representation of nature, whose genealogy in modern times extended from the English painters John Constable and William Turner to the Impressionists, in particular Claude Monet, has at present largely lost its firm place in the canon of art. Doig is turning to nature once more, subjecting it to intensive questioning, investigating it, and trying out various painting surfaces for its changed aspect today – and in doing so, has rediscovered it.

In his youth, Doig led an unsettled life; the family moved house often, going in 1962 to Trinidad, where he now lives once more, and in 1966 to Canada. The intensive experience of non-European landscapes is reflected in his work, as is the non-sedentary nature of mankind. Doig invokes his own varied landscape experiences, capturing his very individual impressions on canvas; in addition, he takes inspiration from photographs, not infrequently taken from the media, from snapshots, from postcards and travel-brochures. The material on which he bases his work is, he says, not particularly interesting or unusual. "But that is intentional. I like this incompleteness. It leaves me a lot of space to find my own images."

But in his landscape painting, Doig dispenses not only with taking a direct look at nature himself, but also tries to maintain the greatest possible detachment from his motifs. Thus for example he works from photographs and sketches which, by repeated reworking, are several generations removed from the originals. He proceeds from the matrix of his own, continually reworked views, which during the painting process he transforms into constantly changing templates, and which he then pushes into each other until an internal map appears for the mental orientation of his own opinions.

In *Canoe – Lake*, a theme on which he has painted several variations, a stage is set up for individual views of a natural spectacle. This implies that a natural scene does not mean something unchanging, but only provides a first stimulus, which in the course of the artistic transformation is pursued further.

Thus anyone who thinks that *Pelican (Stag)* is to be located in the Caribbean is also mistaken. The source of inspiration for the Caribbean cliché image was a postcard from India. "These are not pictures of the Caribbean," says Doig in his studio in Port of Spain in answer to Hilke Wagner, who then suggests a comparison with René Magritte's painted reflections where the relationship between image and reality is concerned. Nothing in Doig's double-edged painting is what it seems. The place may be tropical, but the fleeting protagonist, under the spell of a will o' the wisp in the clearing, is not a tourist in an island paradise, but is showing beholders the way into the broad expanses of their own inner worlds.

The painter enchants us with his playfully imagined configuration of a fantasy in which only the absolutely essential prerequisites are laid out. His art consists in the arrangement of innovative colour variations and just a few formal demarcation lines, whose fluid transitions create an internal tension. Doig looks without any preconceptions and deliberately naively at an ancient topos of art history, in order to rediscover it for himself and for us.

> "ı don't think of my paintings as being at all realistic. ı think of them as being derived more from within the head than from what's out there in front of you."
>
> **Peter Doig**

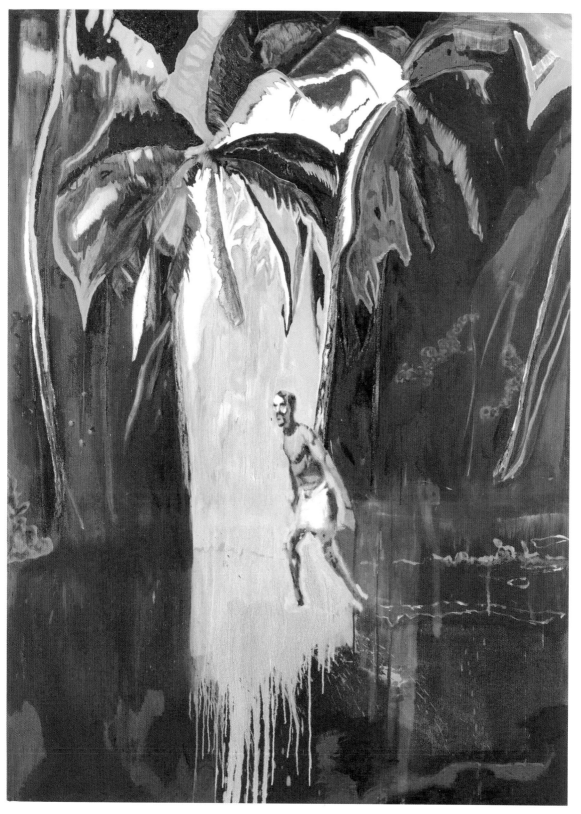

To stay informed about upcoming TASCHEN titles, please request our magazine at www.taschen.com or write to TASCHEN America, 6671 Sunset Boulevard, Suite 1508, USA–Los Angeles, CA 90028, Fax: +1-323-463.442. We will be happy to send you a free copy of our magazine which is filled with information about all of our books.

© 2005 TASCHEN GmbH
Hohenzollernring 53, D-50672 Köln
www.taschen.com

Editorial coordination: Sabine Bleßmann, Cologne
Design: Sense/Net, Andy Disl and Birgit Reber, Cologne
Production: Tina Ciborowius, Cologne
Translation: Michael Scuffil, Leverkusen

Printed in Germany
ISBN 3-8228-2954-4

page 1
ODILON REDON

Head of a Martyr in a Bowl
1877, charcoal and chalk on paper, 37 x 36 cm
Otterlo, Rijksmuseum Kröller-Müller

page 2
JAMES ENSOR

Skeletons in the Studio
1900, oil on canvas, 111 x 79.5 cm
Ottawa, National Gallery of Canada

page 4
GUSTAVE MOREAU

The Unicorns
1885/1888, oil on canvas, 115 x 90 cm
Paris, Musée Gustave Moreau